Angst, Arbe, Asylm, Augor, Axis, Bash, b Roberts (Bad Bob the ... b, oberts, Chaz, Chris, Chub... nd Rick One), Cryptik, Czer One, Defer, d Crae, Dye5, Earn One, Eder, Elika, eOne, Fearo, Fishe, Gabe88, Gasoline, Heaven, Hex (LOD), Hex One (TGO), e One, Jero and Each, Joker One, K4P P (Chelo, Noek, Notik), Kaos, Kasl, Keo Kost One, Kozem, Krenz (Yem), Krush, Mach Five, Mandoe, Man One, Mark7, cNak, Owen One, Panic One, Patrick ay One, Playboy Eddie, Plek One, Pletk e, Pyro One, Rayo, Relik, Relm, Retna, l, Roder 169, Saber, Sacred 194, Sel, Ser, kez, Skill, Slick, SomeOne, Soon One, Tempt, Test, Thanks One, Thel, Trigz, e, Vyal, Werc, Wise, Wisk, Woier, Zes

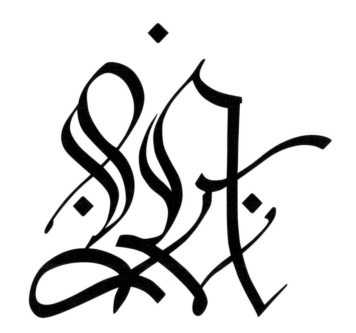

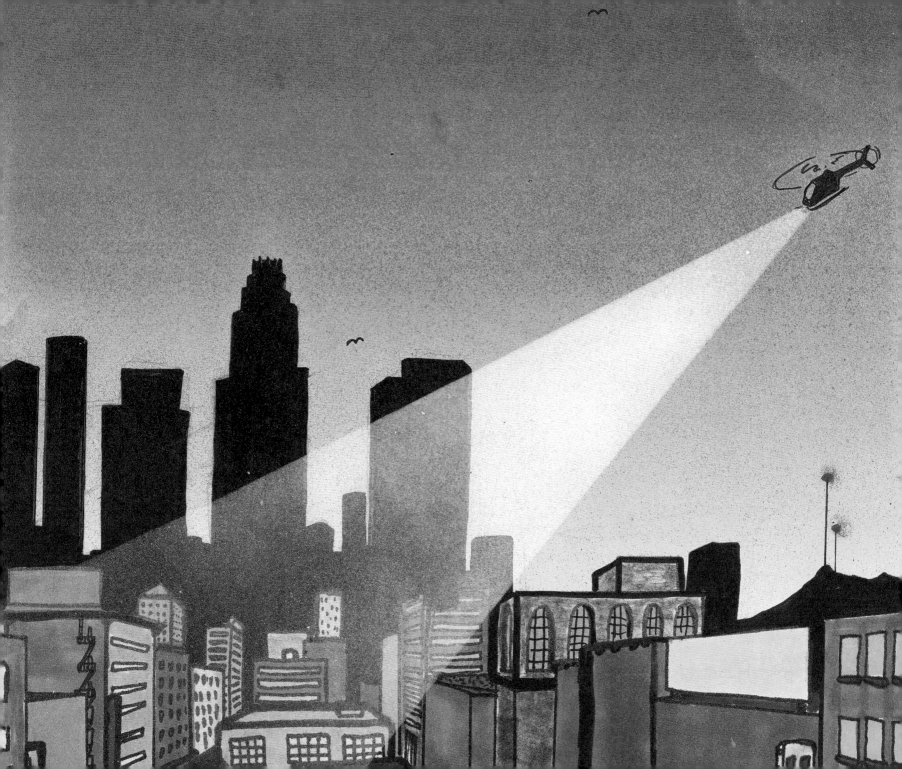

L.A. GRAFFITI BLACK BOOK

DAVID BRAFMAN

GETTY RESEARCH INSTITUTE

LOS ANGELES

To Ed and Brandy Sweeney
and all the artists in this L.A. book of friends

CONTENTS

FOREWORD

Graffiti artists know the concrete landscape of a city better than anyone. Their search for the perfect surface necessitates a closer reading of the urban environment than most residents ever undertake. A similarly focused look at graffiti and street art reveals important aspects of the cultural landscape of Los Angeles, one of the most diverse cities in the United States.

The *Getty Black Book* was conceived as a broad effort to collect disparate voices, intentions, and styles into the same space and to bring together artists who might never have crossed paths. It recognizes an art form that permeates visual culture worldwide more than fifty years after its urban explosion in the late 1960s.

This volume includes works by prolific street artists reluctantly drawn into the limelight by admiring crewmates and fans. Some prefer to remain anonymous, known only by their street monikers, as their practice carries the danger that comes with protest and opposition to societal norms. Their art discloses as much about their identities as they want us to know.

Many masters of the L.A. graffiti movement remain active, though their works no longer materialize on dry river basins or freeway underpasses. Instead, these highly regarded contemporary artists are invited to participate in public art projects and to exhibit at galleries and museums. Among the many who appear in this book is Charles "Chaz" Bojórquez, who grew up in Highland Park. Chaz engaged in graffiti at night while attending the art school that would become CalArts. His calligraphic letters are partly inspired by Cholo-style writing, invented by Mexican American writers in the 1940s. His work resides in numerous collections, including that of the Smithsonian American Art Museum.

Alex "Defer" Kizu has been part of the L.A. scene since the 1980s. He works in multiple media, including markers, spray paint, acrylic, and gouache. He is known for a distinctive hand style incorporating elements of Islamic and Japanese art. His work has been featured in galleries and museums, including the Pasadena Museum of California Art.

Juan Carlos "Heaven" Muñoz Hernandez was raised in Boyle Heights, where he was immersed in graffiti and aerosol mural painting. He was selected by sculptor Robert Graham for the Torso Project at the Museum of Contemporary Art, Los Angeles. He continues to work at the Robert Graham studio and to exhibit his artwork widely.

Enk One grew up in Compton. He participated in the group mural *Our Mighty Contribution*—popularly known as *The Great Wall of Crenshaw*—and the Maya Angelou Mural Festival. His work is about "merging the old with the new . . . showing the African influence in aerosol art and hip-hop culture."

Petal, or Peligro Abejas (Danger Beez), has been writing graffiti since the early 1990s, often with collaborator Blosm. Her style is influenced by her Middle Eastern heritage and by Arabic, Cholo, and Old English scripts. She is known for her iconic bee symbols, which convey the dangers of pollution and the importance of bees to the ecosystem.

Gajin "Hyde" Fujita was a graffiti writer as a teenager, before earning degrees from Otis College of Art and Design and the University of Nevada. Today his large-scale wood panel paintings mix references to traditional Japanese ukiyo-e woodcuts, contemporary manga, and Western pop culture, and they reside in museums around the world, including the Metropolitan Museum of Art in New York.

AiseBorn's art features elaborate pattern work that draws from *adinkrahene* symbols, mandalas, and sacred geometry. He has created murals throughout L.A., and his work has been featured at the California African American Museum and in a solo exhibition at the Container Yard.

The unique letterforms of Marquis "Retna" Lewis are influenced by hieroglyphics, Asian calligraphy, and Hebrew and Arabic writing. The renowned artist has designed an album cover for Justin Bieber and stage sets for the San Francisco, Seattle, and Washington National Operas.

The L.A. skateboarding scene inspired the art of Push, whose colorful graphic style can be seen on both personal apparel and monumental wall art, including the sixty-foot-high *A New Purpose* mural in Little Tokyo.

Each of the 151 artists who devised unique works on paper for the *Getty Black Book* is part of an important moment in Los Angeles art history—one commemorated by this unprecedented citywide collaborative effort. Cocurated and created by the artists, the unique volume is bound in leather and safely held in the Special Collections of the Getty Research Institute, which includes in its mission the protection, preservation, and study of the historical record of art in Southern California.

Mary Miller
Director
Getty Research Institute

PREFACE

Like scribbles and strike-throughs on a paper manuscript, graffiti revises the urban environment. Overlaid on the signs and symbols of a city, framed by buildings, graffiti artists' wall pieces are complex palimpsests; their illusionistic layered surfaces and perspectives paint alternative landscapes of habitation, different ways of living and doing business. Depending on the angle and the viewer, new meanings become legible and dominant messages are decisively altered by monumental contemporary calligraphy.

Hiding in plain sight, graffiti is art history in the making. Its ciphered self-portraits—biography expressed with personal devices and animated objects—compose a recognizable and stylish language to be interpreted among insiders, practitioners who cite one another. Often a moniker is hard to read and difficult to appreciate unless you're one of the cognoscenti. But this is like all art. Aliens will not know how to interpret *The Last Supper.*

For me, it is easy to see the connections between contemporary graffiti and the history of writing and letterforms. For example, in Europe during the period leading up to the Renaissance, type design, writing masters' manuals, and scribal apprenticeships were the main avenues for learning how to shape letters. Large initials had spaces to be filled with fantastic animals, plants, and figures doing surprising things. Even in the Middle Ages, a single letter or word could bear its own idea. So when Ed Sweeney called me with his plan to fill a book with works by Los Angeles graffiti artists and donate it to the Getty Research Institute (GRI), it made perfect sense. The timing was good, too, because the Getty was in the process of adjusting its vision of art focusing on Los Angeles and the contemporary era. In preparation for the initial Pacific Standard Time exhibitions of 2011, we were encouraged to collect with a global view of the cultural traditions that flow together in Los Angeles. Getty endeavors to "connect art histories," not only around the world but also in our own city. Our collections are not just for scholars; they demonstrate the importance of preserving diverse cultural legacies for public constituencies of all ages, including children.

For those of us steeped in the traditional discipline of art history, the *Getty Black Book* brought a refreshing focus. It zoomed in on local art and artists: underrecognized communities of graffiti and tattoo artists who draw inspiration from their own backgrounds, including Latin American, African American, and Asian American cultures. When the artists, with their families and friends, came to GRI Special Collections for visits organized by David Brafman and assisted by Lisa Cambier, I joined them when I could. This was both exciting and rewarding to me personally—nothing is more fun than looking at books in Special Collections with people who appreciate them. The *Getty Black Book* has been much requested since it entered our collections, and it is only appropriate to share it with wider audiences through the publication of this volume.

Marcia Reed
Chief Curator and Associate Director
Getty Research Institute

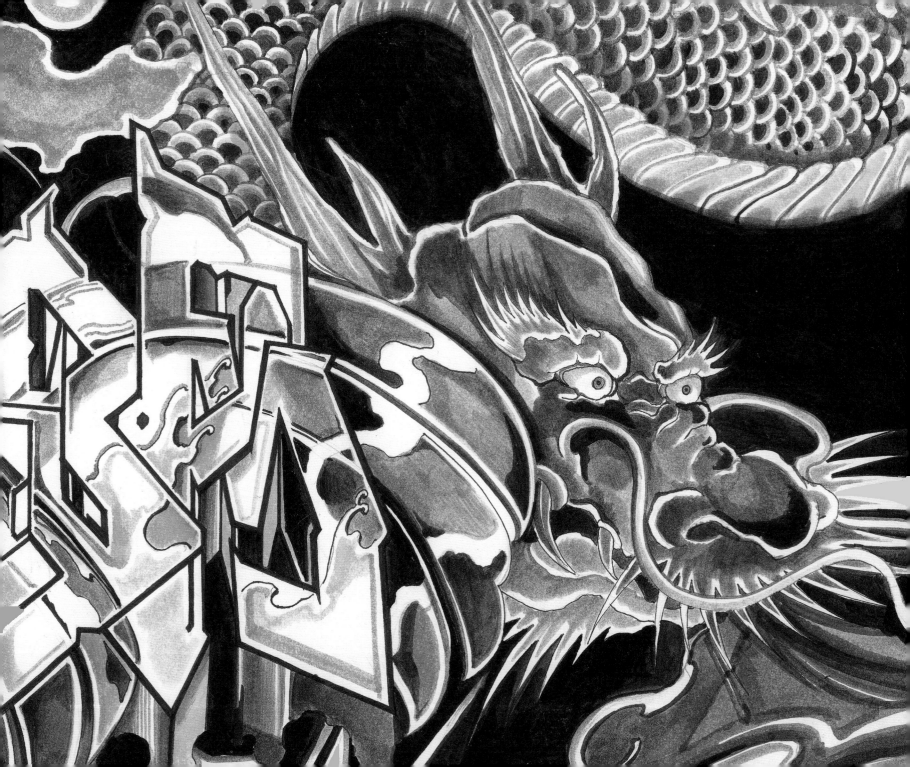

From blood and chalk on the cave walls of France and Spain to atomic bombs burning our shadows into the cities of future ruin, graffiti has always been here, and it is here to stay. Artists persevere, but graffiti is not art; it is an act of defiance. Graffiti is evidence . . . landmarks to honor us with. We are the roaches, the crocodiles, and the coyotes. We aren't kings or rock stars! Graffiti is community, it is kinship, and pure celebration. Graffiti isn't egos, money, or esteem. Graffiti is the anti-art. . . . To quote Barnett Newman, "I make paintings to destroy the wall."

—Kyle "Kyote" Thomas

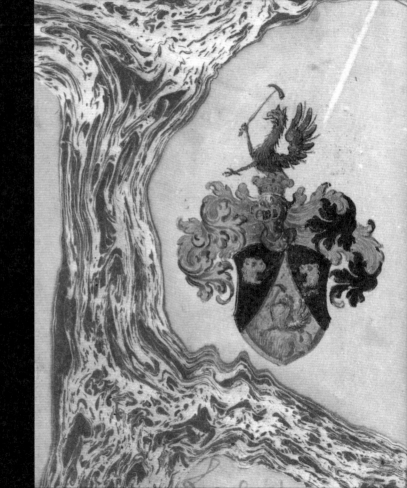

AN L.A. BOOK OF FRIENDS

Letters exist in a divine realm, combining and descending to illuminate us.

—Abū Nasr al-Fārābī (Iranian, ca. 870–943), *Kitāb al-hurūf* (Book of Letters)

All books are picture books, whether they are illustrated or not. The printed or handwritten words that fill them are themselves images—ones whose meanings are contemplated and remembered when written, read, recited, or chanted. (Words are both symbols and sounds. A sentence is like a line of music.) The nature of the word as a pictorial, even material, entity may be embodied nowhere more tangibly than in the realms of tattoo art and graffiti. Tattoo needles stab personal meanings into inky permanence on flesh; tag names writ large glorify the colors secreted from a nozzle as much as the aliases of their secret creators.

The ancient Greek word *graphein* meant "to scratch," "draw," or "paint" long before it came to mean "to write." *Graffito* is old Italian slang for "little mark." Graffiti writers leave their marks on the world, whether others like it or not. The human urge to permanently manifest one's identity for all to see is fundamental to creative expression, as visceral as commemorating love by carving initials into a tree.

I first experienced my own hands-on encounter with graffiti during high school—at Erasmus, in Brooklyn. My friends on the block finally invited me on a late-night mission to tag the subway cars sleeping in the Brooklyn rail yards. At first I stood there, shifting around, feeling jealous and inadequate. They could do something I couldn't: knock out a mural or

Is graffiti vandalism or art? Yes.

—Angst

FIGURE 1

An entry in a book of friends shows a family crest crowned by a griffin that wields a pickax and seems poised to chip away at the marbling created earlier by a Muslim papermaker. From Johann Joachim Prack von Asch (Austrian, act. 1587–1612), *Liber Amicorum* (Book of Friends), 1587–1612. Los Angeles, Getty Research Institute, 2013.M.24.

> It took ten years to even tell myself that graffiti is an art form. . . . But in my heart I knew that it was a language that I wanted to discover but also to use as a tool and to create my own language out of it.
>
> —Chaz

monumental word across a fifty-foot train car, just by stepping back, eyeing it, and wham-o, projecting the scale from their heads onto the corrugated surface. My posture got progressively slouchier as I watched them, until I remembered what I had on me: a ragged copy of the Egyptian *Book of the Dead* I had found days earlier in a bookstore bin. I grabbed a can and spritzed out glyphs of ibis-headed Thoth, god of scribes, and some Eyes of Horus onto a few passenger windows. For a while afterward, spray painting Egyptian hieroglyphics in and on D trains became my favorite pastime.

That is basically the beginning of my ending up as a curator at the Getty Research Institute (GRI), looking at the history of books and manuscripts that make art out of words with brush, pen, and print. It also sums up the extent of my hands-on engagement with street art until 2012, when Marcia Reed, chief curator at the GRI, introduced me to Ed and Brandy Sweeney, a local couple dedicated to collecting and bringing attention to the graffiti art of Los Angeles. The Sweeneys proposed the idea for the project that would become the *Getty Black Book*.

Many graffiti artists carry sketchbooks they call black books or piece books. They ask friends, crew members, and others whose work they admire to "hit up" their books—to fill a blank page with artwork, whether a simple drawing, freestyle lettering, or an elaborate composition. What if, the Sweeneys asked, we reached out to crews across the city to hit up a black book for the Getty? To create a citywide compendium of Los Angeles street writers—a multivoice "master-piece" book for the twenty-first century?

The Sweeneys introduced me not only to a brilliant concept but also to some of the most talented and creative people I now know. They invited artists including Angst, Axis, Big Sleeps, Chaz, King Cre8, Defer, EyeOne, Fishe, Heaven, Hyde, Look, Man One, and Prime to Getty to consider their idea. I feverishly prepped for the meetings by pulling from the vaults a show-and-tell of rare books (figs. 1–8) that I had either encountered in or acquired for the collection over the years—books that somehow, nebulously, resonated in my memory with nights in the Brooklyn rail yards.

Together we pored over early calligraphy manuals brimming with elaborate and quirky letterforms (fig. 3), emblem books rich in inventive symbolism expressly designed to make a mark on memory, calligraphic Arabic verses contemplated by Islamic pilgrims on the Hajj, an eighteenth-century book claiming to decipher Peruvian Quipu knot language, volumes

> My style has evolved throughout the years— from letter-based structures to now a more fluid and gestural abstract style, which I call "Spiritual Language." It essentially obliterates the structured letterform.
>
> —Defer

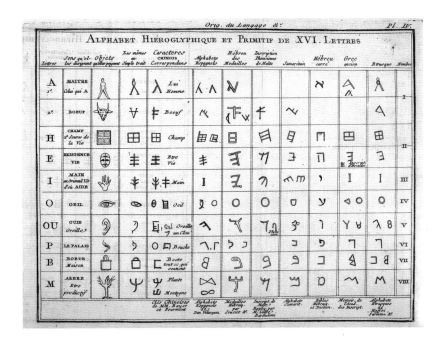

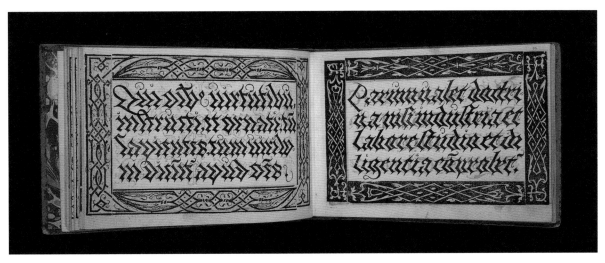

FIGURE 2

This chart suggests that the shapes of letters evolved from forms that prehistoric artists observed in the world around them. From Antoine Court de Gébelin (French, 1725–1784), *Monde primitif, analysé et comparé avec le monde moderne, considéré dans l'histoire naturelle de la parole: Ou Origine du langage et de l'ecriture* (The Primitive World Analyzed and Compared with the Modern World, Considered within the Natural History of the Word: Or the Origin of Language and Writing), 1775. Los Angeles, Getty Research Institute, 91-B27851.

FIGURE 3

Pages from a calligraphy primer by writing master Urban Wyss (Swiss, d. 1561), *Libellus Valde Doctus Elegans, et Utilis, Multa et Varia Scribendarum Literarum Genera Complectens* (Elegant and Useful Treatise on the Learned Art of Writing), 1564. Los Angeles, Getty Research Institute, 2729-609.

I related to these rare books as one who recognizes a colleague in arms. Had I been born in an earlier age, I would have been a scribe.
—Angst

The black book in many ways is a peephole into the evolution of lettering and sacred text, the advancement of stylization to symbols and characters around letterforms.
—AiseBorn

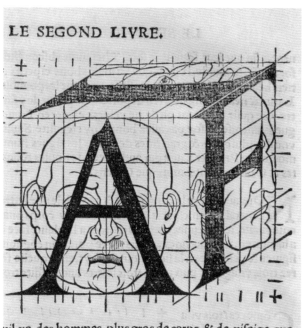

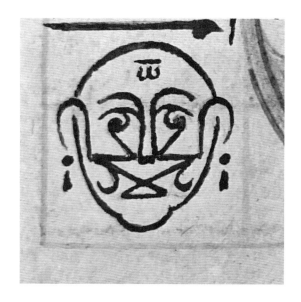

FIGURE 4
Pioneering font designer and printer Geoffroy Tory (French, ca. 1480–ca. 1533) demonstrated how geometric proportion can be applied to both letterforms and the human form. From *Champ Fleury, ou l'art et science de la proportion des lettres* (Champ Fleury, or the Art and Science of the Proportion of Letters), 1529. Los Angeles, Getty Research Institute, 84-B7072.

FIGURE 5
The sketchbook of a nineteenth-century Kolkata teenager includes his drawing of a human face composed of Arabic calligraphic letters sacred in Islam. Merza Mohammad Hadee (Indian, b. 1829), *Insān kāmil* (Perfected Man) from *Kanz al-hādī* (Hadi's Treasure Trove), 1865. Los Angeles, Getty Research Institute, 2015.M.40.

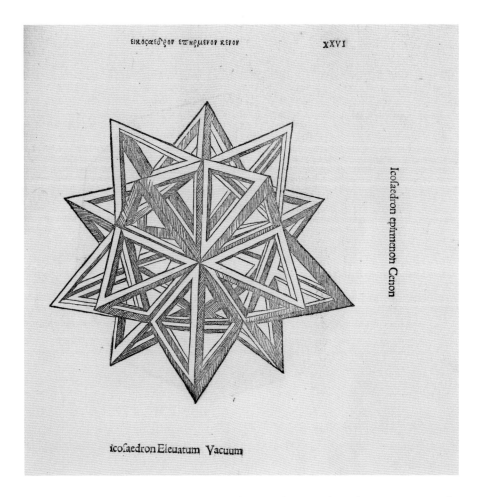

EIKOGAEΣΘOV EΠHEMEVOV REΠOV XXVI

icoſaedron epiſirmon Cenon

icoſaedron Eleuatum Vacuum

Art mirrors, because it loves, nature—good news born out of darkness. At heart, controlled chaos always propels my work. A world of infinitely combining geometry and constantly blending colors eventually creates angle angels and chemical weddings.
—Juan Carlos "Heaven" Muñoz Hernandez

FIGURE 6
This woodcut designed by Leonardo da Vinci (Italian, 1452–1519) purports to show an atom of water, one of the four classical elements (with fire, air, and earth) as understood by the ancient Greek theory of Platonic solids. From Luca Pacioli (Italian, ca. 1445–ca. 1514), *Divina Proportione* (On Divine Proportion), 1509. Los Angeles, Getty Research Institute, 84-B9582.

of pseudoscientific phonetics, exotic alphabets, and more. I brought out Luca Pacioli's stunning *Divina Proportione* (On Divine Proportion; fig. 6), printed in 1509, with woodcuts designed by Leonardo da Vinci, which perpetuated ancient Greek and medieval Islamic theories of how to geometrically map and visualize the physical world. The four ancient elements—fire, air, earth, and water—were thought to be composed of geometrically shaped atoms (otherwise known as the Platonic solids), while the divine realm of heaven was

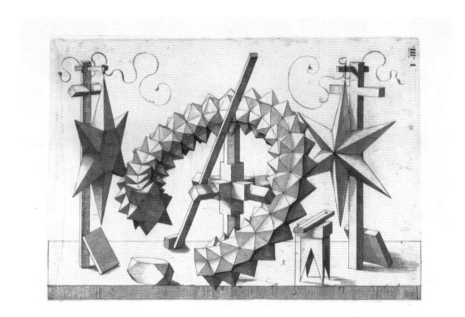

composed of aether, the fifth element. Also examined was Wenzel Jamnitzer's *Perspectiva Corporum Regularium* (Perspective of Regular Bodies; fig. 7), which riffs on the five elements by imagining their atomic forms using the shapes of the five vowels of the alphabet. The artists' bond with the books was immediate; they intuitively recognized the connections to their own artistic practices.

The book that exerted the most powerful pull on the visiting artists was a seventeenth-century *liber amicorum* (book of friends), an elaborate form of autograph book that had become a fad among university students, aristocrats, and academics in the mid-1500s (fig. 8). Passed from hand to hand, a *liber amicorum* was filled with calligraphic signatures, poetry, and painted coats of arms, like a black book from four hundred years ago.

Inspired by this meeting of minds across the centuries, this core group of artists became both creators and curators, crafting pages for the black-book-to-be and distributing paper to members of their own crews to fill however they wanted. Eventually, 151 Los Angeles graffiti and tattoo artists hit up 143 individual pages.

FIGURE 7
This etching depicts the fifth element—the divine substance of heaven—employing the universal geometric forms that shape the five vowels. From Wenzel Jamnitzer (German, 1507/8–1585), *Perspectiva Corporum Regularium* (Perspective of Regular Bodies), 1568. Etchings by Jost Amman (Swiss, 1539–1591, act. Germany). Los Angeles, Getty Research Institute, 2578-543.

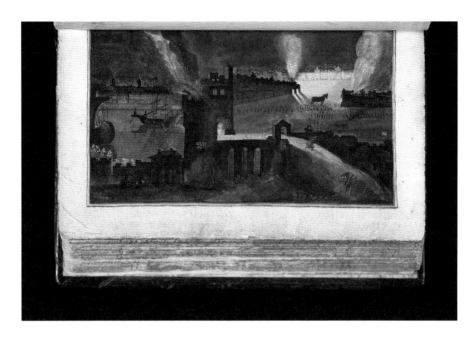

Enk One, an artist from King Cre8's crew, echoed a painted page in Johann Heinrich Gruber's seventeenth-century *liber amicorum* to express the urgency of an artist's voice in a "historic moment in time," whether the apocalyptic end of the fabled city and civilization of Troy or Los Angeles slipping into the sea as it loses its balance, whether tectonically or ethically. Fishe emulated early modern European emblems for his page in the book. Emblematic symbols were close kin to the heraldic shields found in friendship books (see fig. 1), but they were created by those whose families were not historically endowed with aristocratic coats of arms. The icon Fishe found most expressive of his personal artistic identity was a Maya pyramid crowned with a rising sun amid an outcrop of hallucinogenic mushrooms; inserted among the fungi are Pacioliesque polyhedra inspired by Fishe's Getty visit. For street writers like Fishe, the world is composed of ornamental atoms awaiting artistic form.

No matter the chosen form or theme of expression, virtually all of the art in the *Getty Black Book* shares a common bond: mastery of mechanical techniques to manifest an artistic voice and personal vision.

FIGURE 8

A miniature painting in ink and watercolor of the sack of Troy by Tobias Bernhard (German, 1578–1621) is included in this friendship book. From Johann Heinrich Gruber (German, act. ca. 1602–12), *Liber Amicorum* (Book of Friends), ca. 1602–12. Los Angeles, Getty Research Institute, 87-A171.

> Perfection in the execution of hand-style lettering is enhanced by incarceration.
> —David "Big Sleeps" Rodriguez

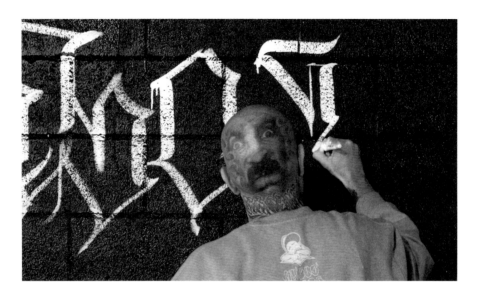

> The agility and ability of the artist working with aerosol . . . is evident through motions and structural order when paint is released under high and low pressure being controlled by the index finger. There is a degree of athleticism in graffiti writers that should be revered.
> —AiseBorn

FIGURE 9
Master tattooist and calligrapher Big Sleeps has an image of his face tattooed on the back of his head. Photograph by Jim McHugh.

Graffiti art is by nature volatile (from the Latin *volare*, "to fly"), both socially and in execution. It's a furtive form implicitly conscious of its ephemerality; its obliteration can be as sudden as its creation. Time is of the essence, and making materials obey instantly is inherent to the artistic process. In a sense, the permanence endowed by black books such as this one is anathema to aspects of street-writing practice. (But not to tattooing! See fig. 9.) In the *Getty Black Book*, each artist evinced their own peculiar personal relationship with time and material, whether filling a page with practiced, measured letter styles squeaked from a marker in the manner of Big Sleeps or Angst; deftly and carefully rendering dragons with graphite like Defer; enhancing a blazing palm tree (à la Ed Ruscha) by applying glitter, as did Patrick Martinez; or pouring liquid gold onto the page like Blosm and Petal.

Materials have their natural qualities—i.e., chemical urges—and it takes artistic mastery to regulate them. *Solve et coagula* was the alchemical motto and modus operandi of color labs for millennia: "dissolve and blend; separate and bond." In the millennia-old global tradition of painters, dyers, inkers, and printers, the artists in this book tweaked the volatile to achieve the stable and fixed—to get the sticky, waxy, glossy, or washy consistency that makes materials "fall" right when applied and dry right as they adhere to a surface.

Curators tend to be jealous of the relationship artists have with the three-dimensional world. Street artists are like athletes; they plunge in with dexterity and revel in the rush of immersing themselves in surface, depth, and perspective. Words cannot express the sheer tactility with which graffiti artists intuit and embrace space. They feel it in their bones.

The applied results are manifold. For street writers, muralists, and their ilk, Los Angeles is a fantasy canvas of some five thousand square miles, where strength and stealth are requirements for triumphant art. The dangerous challenges of the city's landscape, architecture, or icons become the stuff of mythology when set down on paper. Gasoline's page offers streets as flatland scanned by the matte lamp of a chopper's searchlight, while the perspectival line art of Kofie and the geometric color fields of Heaven beckon us to follow patterns for endlessness into the sublime. King Cre8 re-created himself as a wizard in *The Defender of Style*, his pencil a wand that fends off and dispels the wannabe snaky imitators of his signature style. At the same time, he took a brilliantly playful swipe at the Mickey Mouse sorcerer's apprentice in the Disneyland of a white man's world.

One should always be mindful that the dangers of the street writer's universe are real. The consensus among students of Los Angeles graffiti history is that the lettering style considered the signature "L.A. style" originated on the East Side, and its creator was José "Prime" Reza. In his younger days Prime was caught perfecting his lettering while tagging on unfriendly turf. His right arm—his writing arm—took a blow from a shotgun shell. He consequently trained himself to draw and paint with his left hand. Prime created the elegant cursive "LA" for the cover and spine of the *Getty Black Book* (see p. 12). Note that the lettering is punctuated by three dots embedded at the left, right, and top. The simple graphic gesture denotes "tap, tap, tap"—two shots to the chest, one to the head—a subtle yet blunt reminder of human hostility and fragility.

The 143 pieces of art bound together in the completed *Getty Black Book* comprise a unique artists' book. It is informed by the past but speaks of Los Angeles now, with a creative voice suffused with the city's light, darkness, landscape, and talent. It is a book of former rivals brought together by the common urge to combine their artistic marks, a group of artists who ultimately chose a new official title for their collaborative work: *LA Liber Amicorum*—the Los Angeles Book of Friends.

Graffiti art is the gateway drug to awaken individuals in search of a creative rebellion buried within the layers of a dysfunctional society, resulting as symptoms on walls caught in a vicious cycle as either the cure or the disease.

—Saber

The climate for artists like us has become much more welcoming and open. For better or worse, we are no longer the villains.
—Fishe

Out of all the books I scribbled in from age two to now, I am most proud to have contributed to this one.
—Alex "Axis" Ventura

We had mulled over the idea of an exhibition related to the project and wanted the unveiling of *LA Liber Amicorum* to incite the same excitement among the public that the artists had experienced during their rare-book viewings at Getty Center. So we devised *SCRATCH*, an exhibition and installation and, above all, a curatorial collaboration with the artists (figs. 10–12). The venue of choice was ESMoA (El Segundo Museum of Art), a non-profit experimental art space, with an eighty-two-by-twenty-four-foot gallery, where the artists were invited to participate in a culminating act of creative vandalism perpetuated against the black book.

The *LA Liber Amicorum* the artists had created and the rare books they had pored over were installed in vitrines with iPad page flippers. The "scratchers," as the artists started calling themselves, needed only one curatorial directive: Explode the black book! Splatter it conceptually all over the walls and floor, riffing on all the imagery in the books on display! Crews filled the gallery with their artistic responses to centuries of graphic book arts.

It is one thing to bind rival art crews together alphabetically in a "book of friends." Having them working together in the same space is even better. Fifty to a hundred artists came in and out, leaving their marks twenty-four hours a day for more than a week. Others who had contributed to the *Getty Black Book* made cameo appearances. *SCRATCH* was a lot of work, but it was a breeze to curate. You just had to stay there all night and keep your eyes open.

The *Getty Black Book* is unique; there is just one, an only child born from a collector's creative passion. Access to that unique original, however, is restricted. For a curator of rare books, there is a fine line between the urge to expose it to as many people as humanly possible (part of me wants to let them write in it) and the fear of risking its preservation through exposure.

This printed volume reproduces the pages created by the artists' hands and commemorates an unprecedented collaboration across the diverse artistic landscape of Los Angeles. Like those of friendship books through the centuries, its images and inscriptions are emblems that testify—with brush, pen, aerosol or lens—to memories of human encounter. A lasting memento, it shares with all a moment when personal histories drew leading local artists together to create with one another an L.A. book of friends.

◆ ◆ ◆

There are many things that this project has given me. The one thing I cherish the most is the respect that everyone has for and shown each other. Thank you to everyone who participated. I hope this project serves as a testimony of our unconditional love for the arts and each other *con todo respeto*.
—Prime

Figures 10–12
SCRATCH, the exhibition and installation, at ESMoA, 2014. Photographs by Gloria Plascencia courtesy of ESMoA.

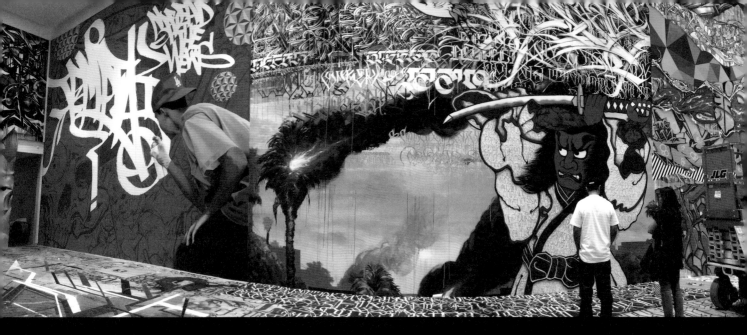

The black book project was an opportunity to bring unsung, talented street artists together in a single place. The original book embraces a zeitgeist of Los Angeles unity, celebrating cultural diversity and talent.
—Brandy Sweeney

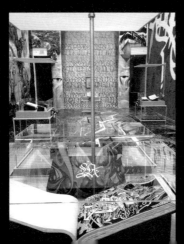

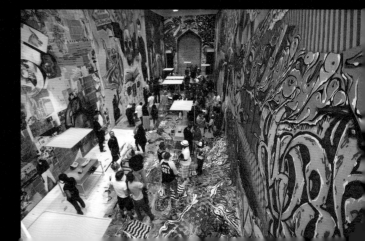

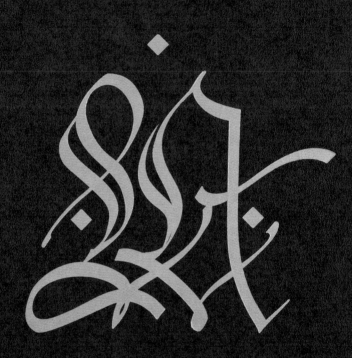

LA Liber Amicorum, 2012. Los Angeles, Getty Research Institute, 2013.M.8. Gift of Ed and Brandy Sweeney

OG Abel

8-19-12

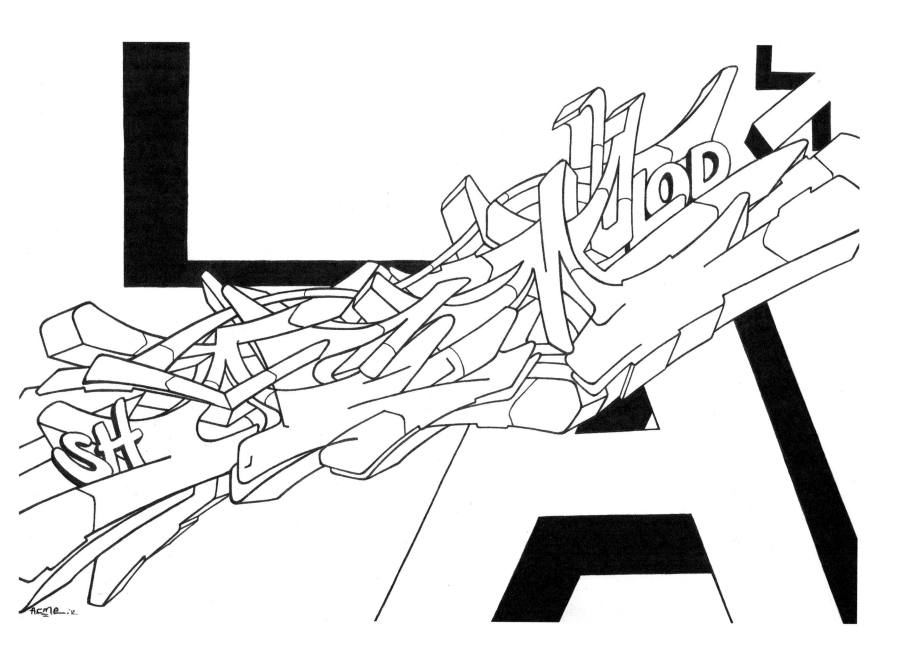

Acme

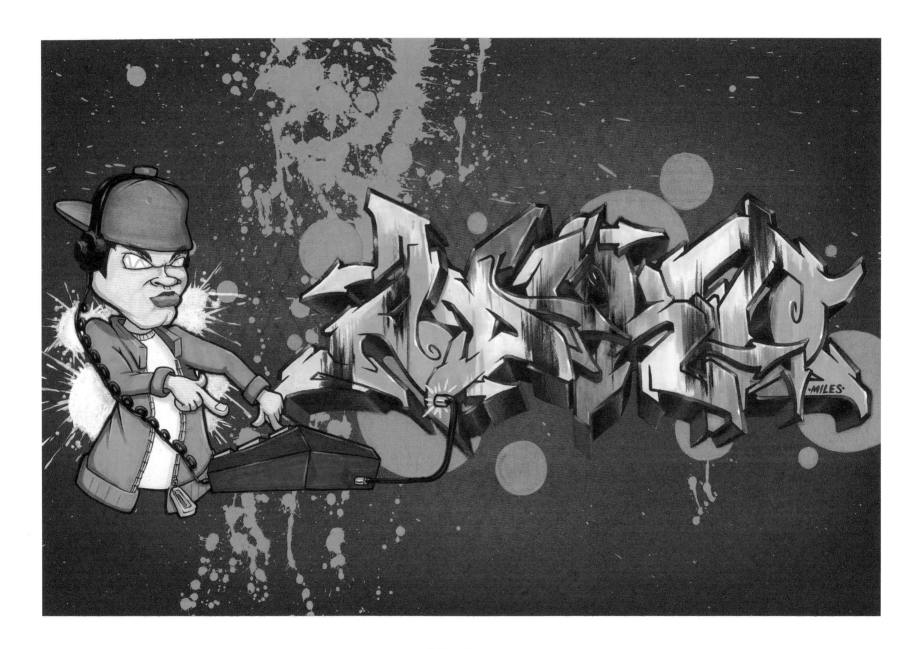

Adict One

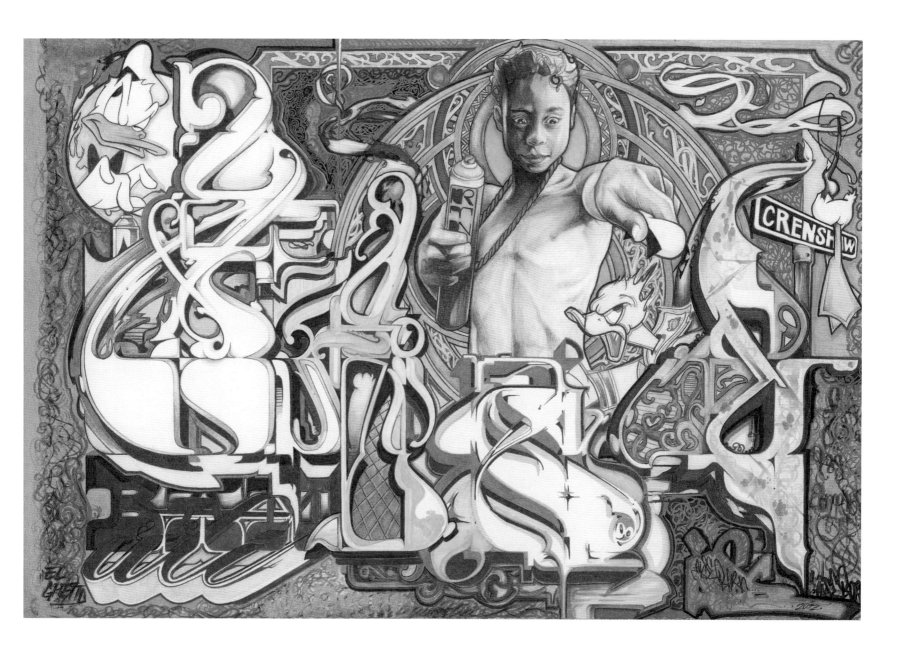

AiseBorn

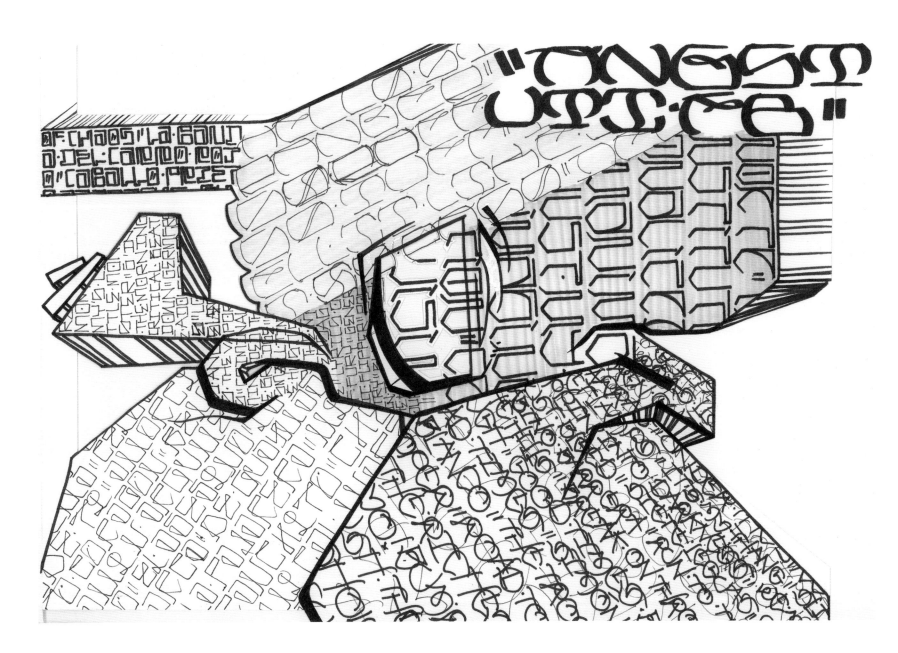

Angst

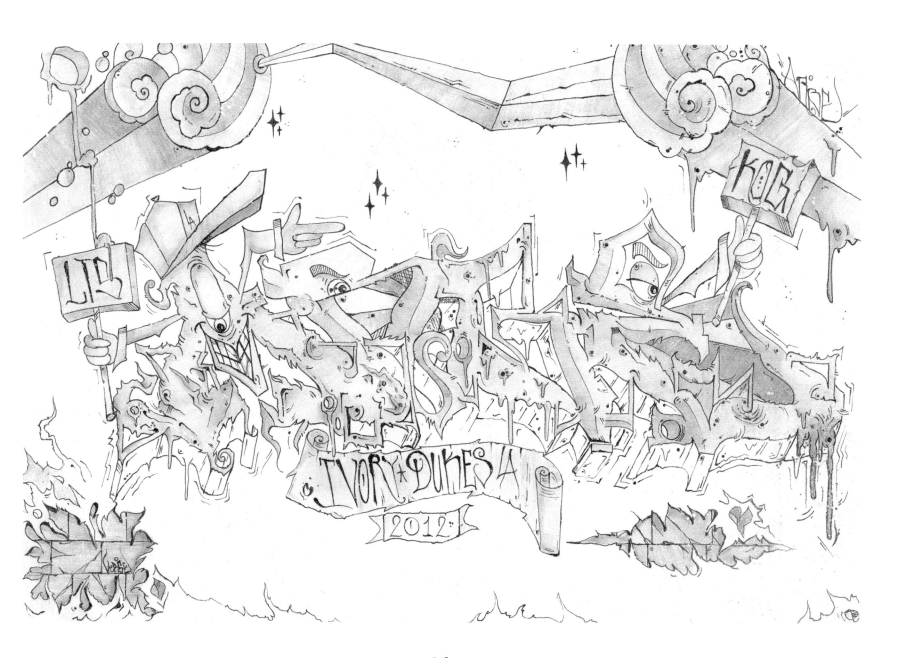

Arbe

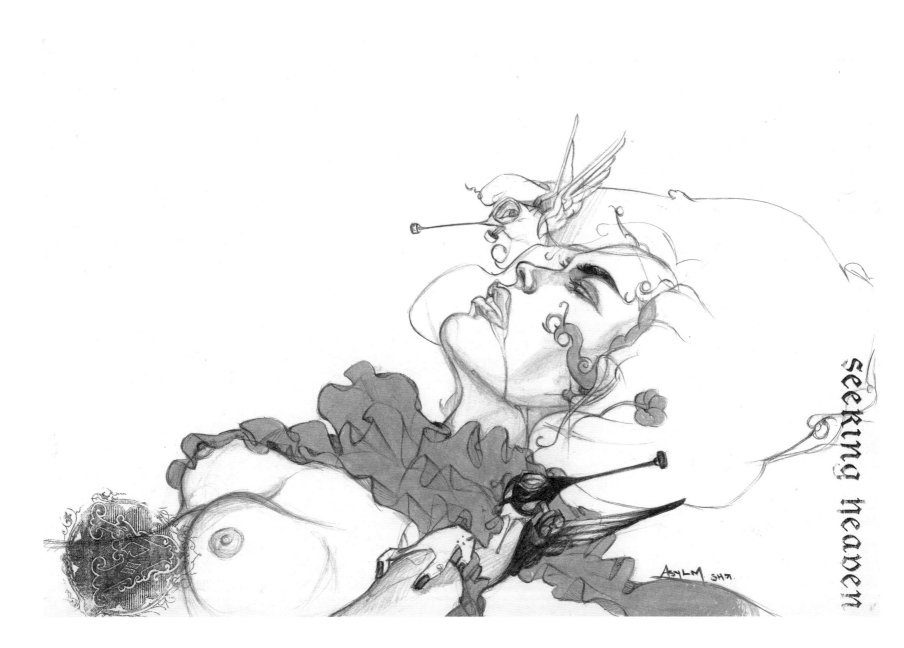

seeking heaven

Asylm

Augor

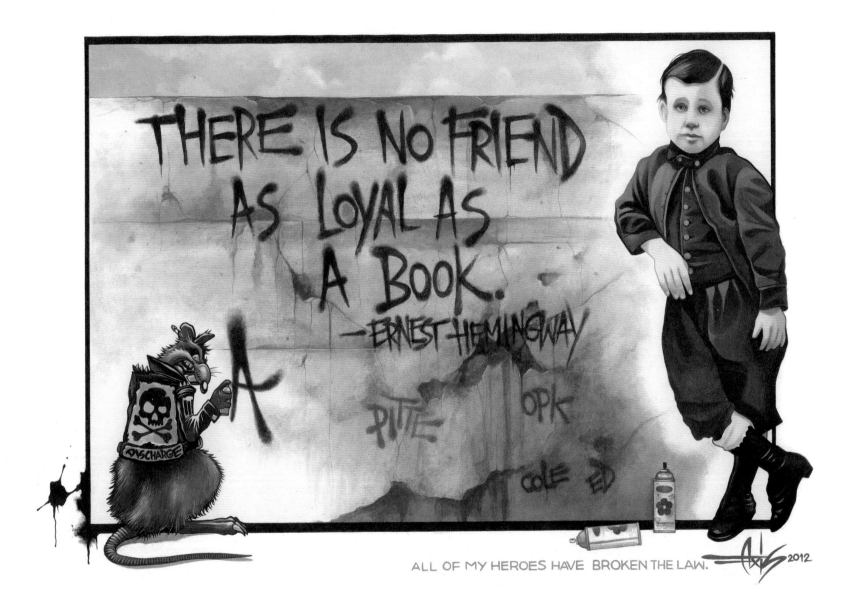

Axis

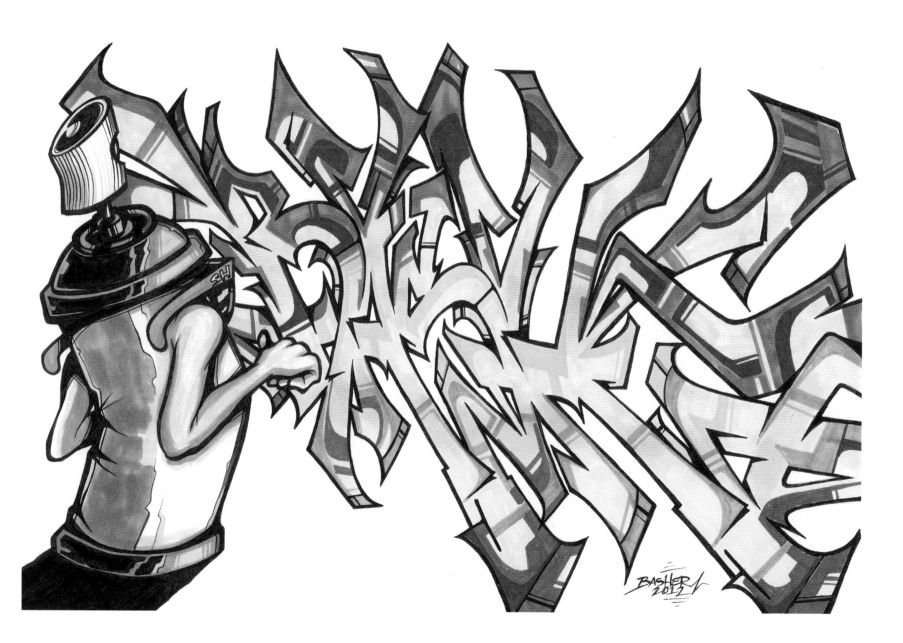

Bash

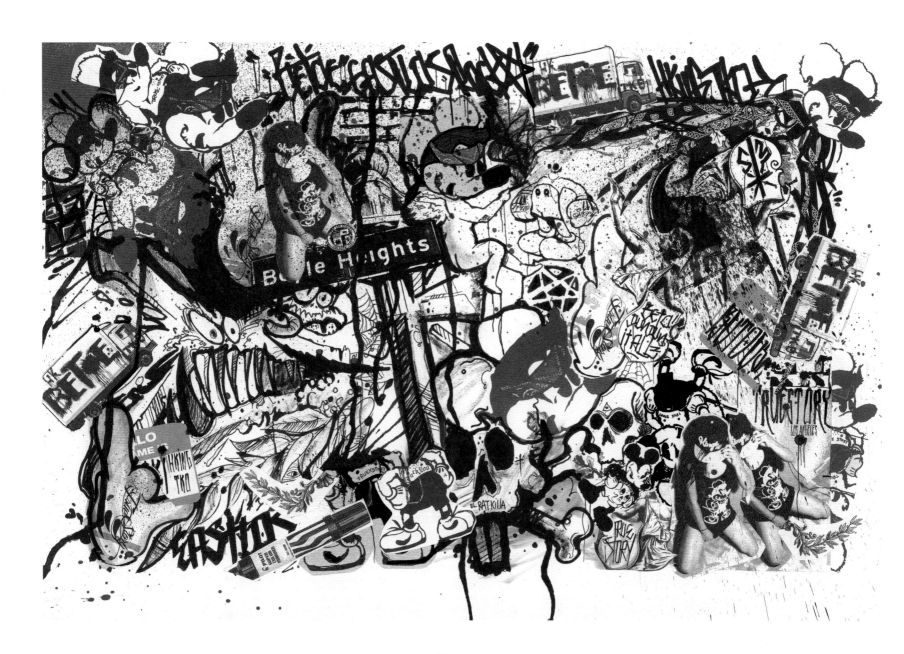

Betoe

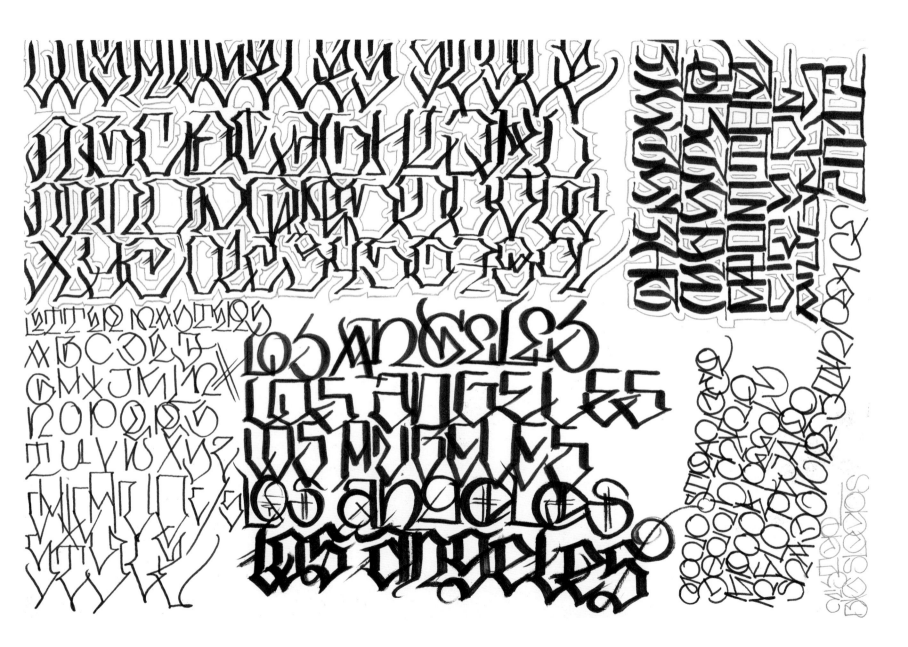

Big Sleeps

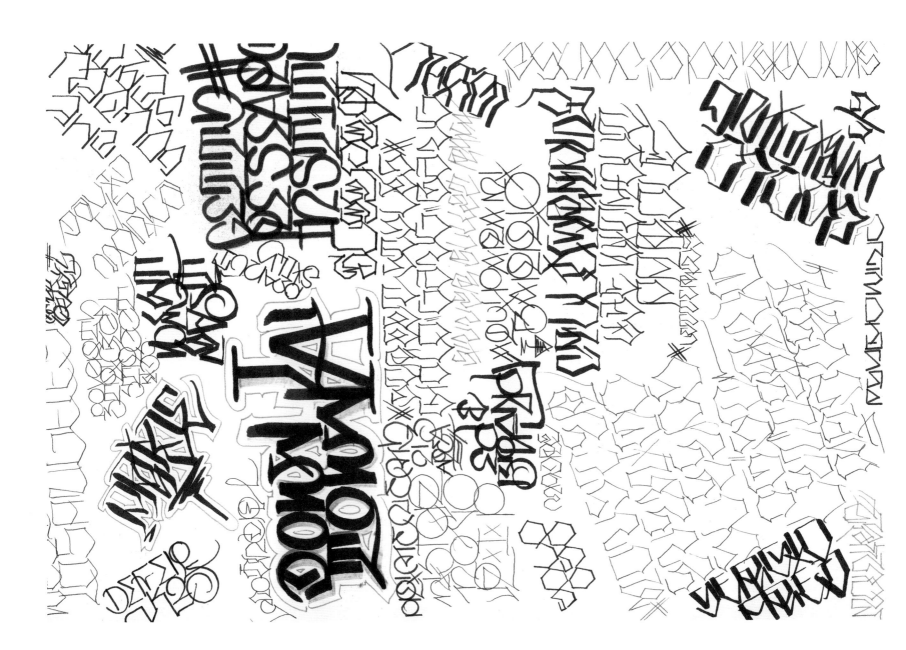

Big Sleeps

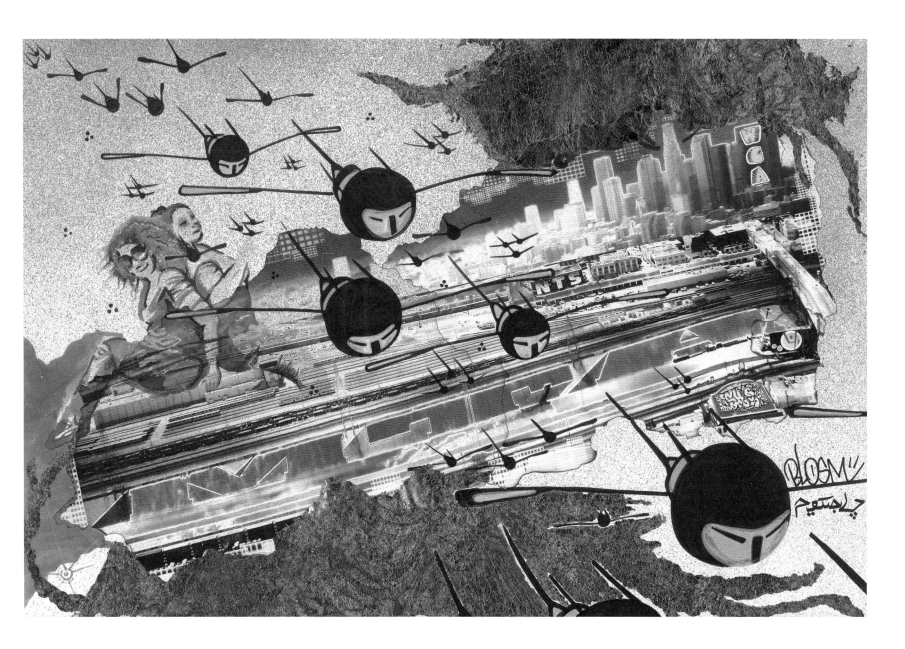

Blosm and Petal

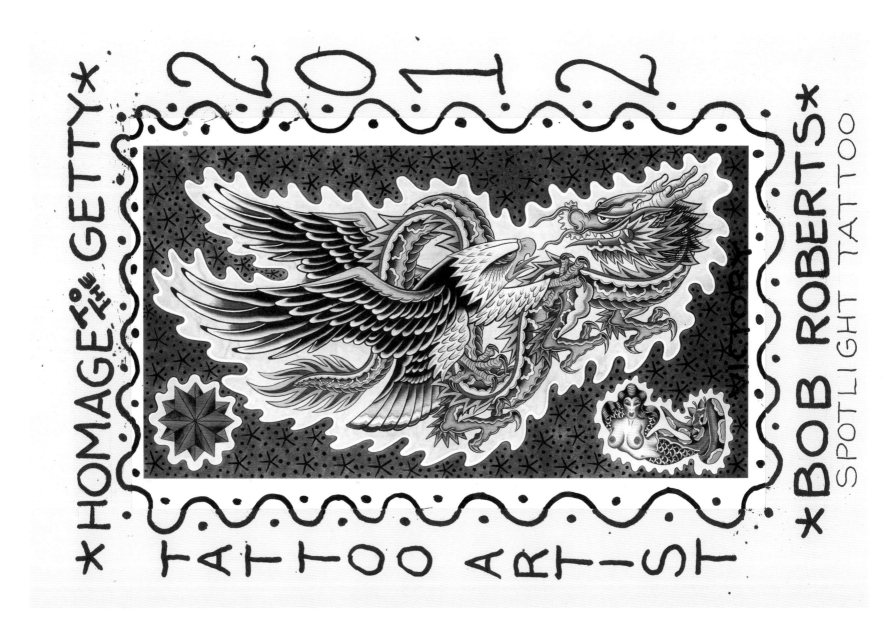

Bob Roberts (Bad Bob the Worst)

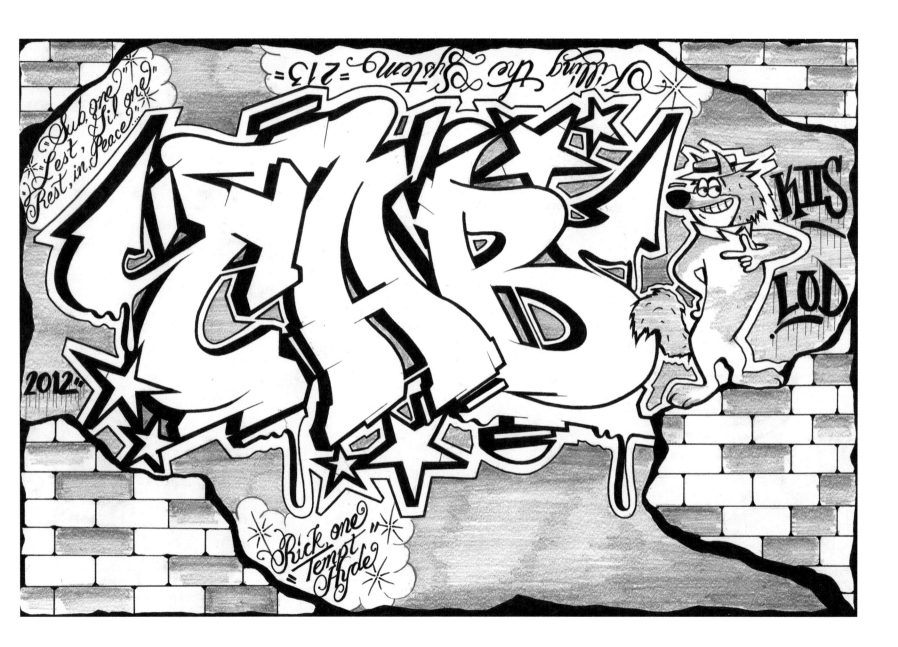

Cab

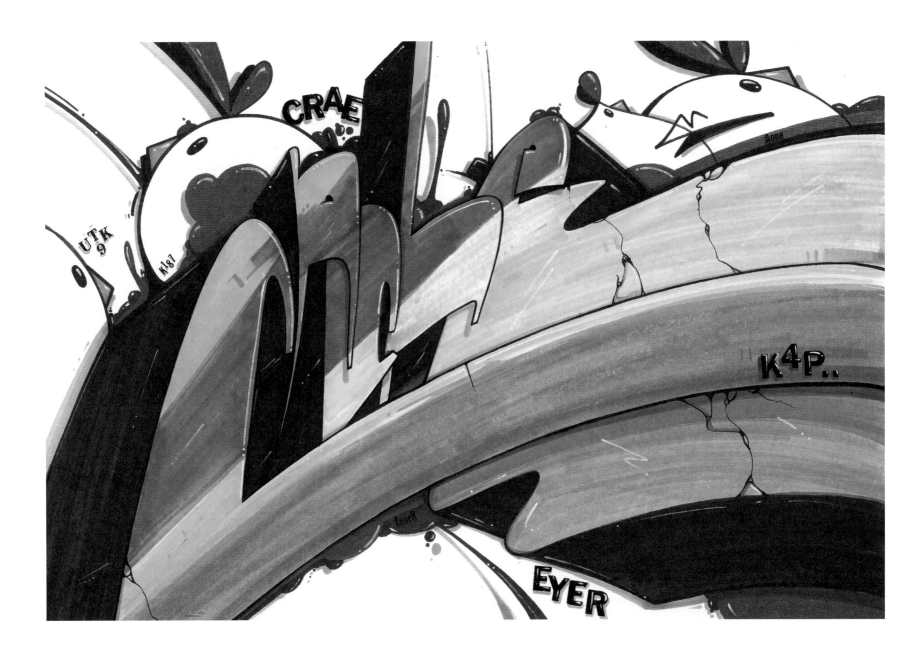

Cache

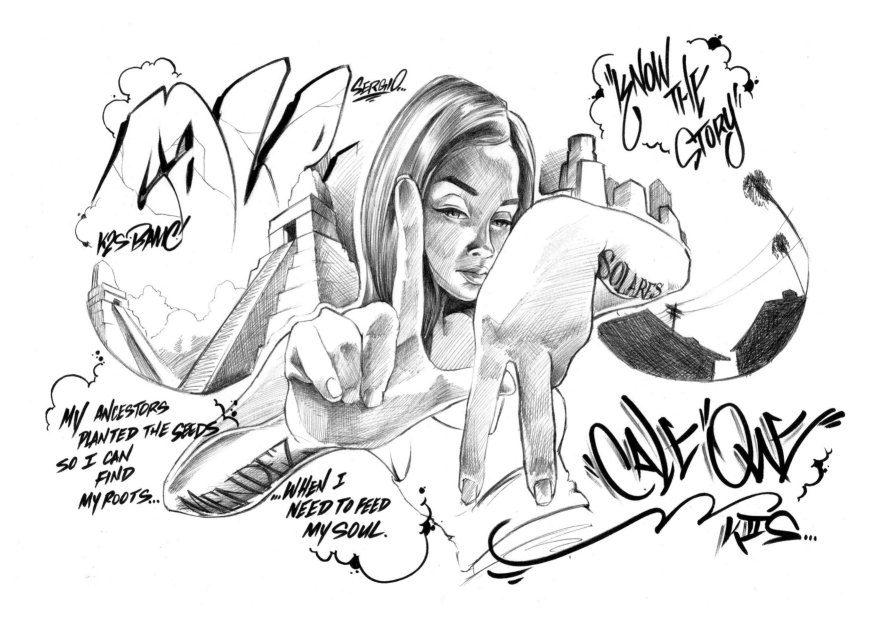

Cale One

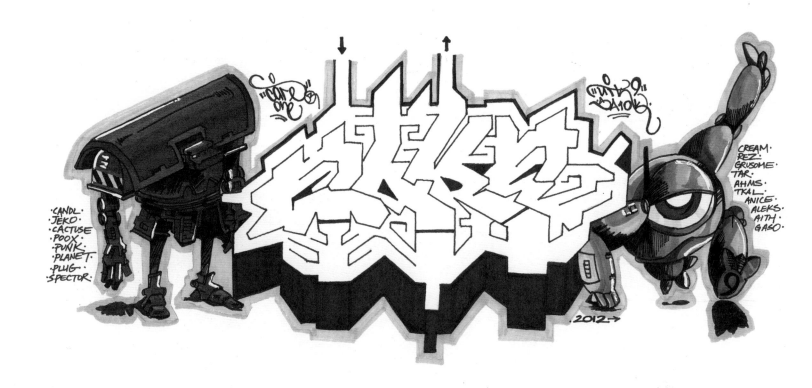

Care One

Charlie Roberts

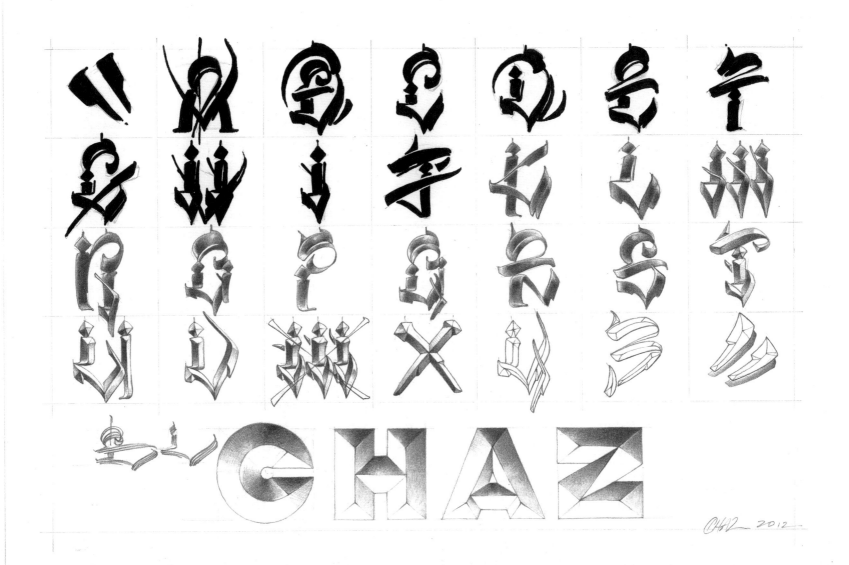

Chaz

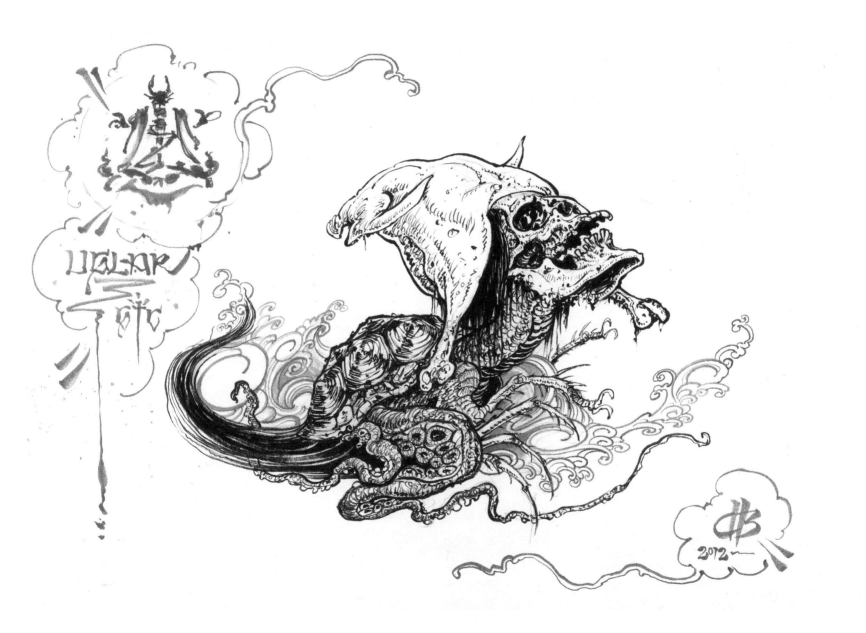

Chris

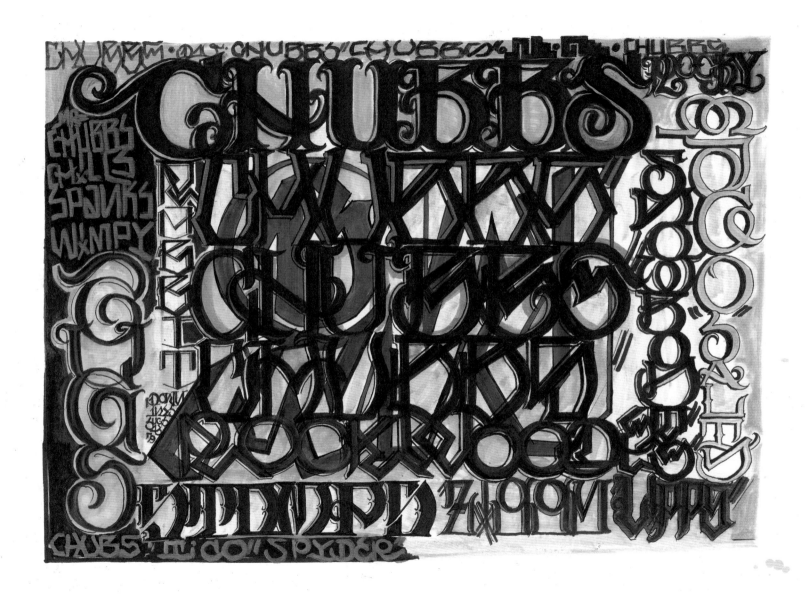

Chubbs

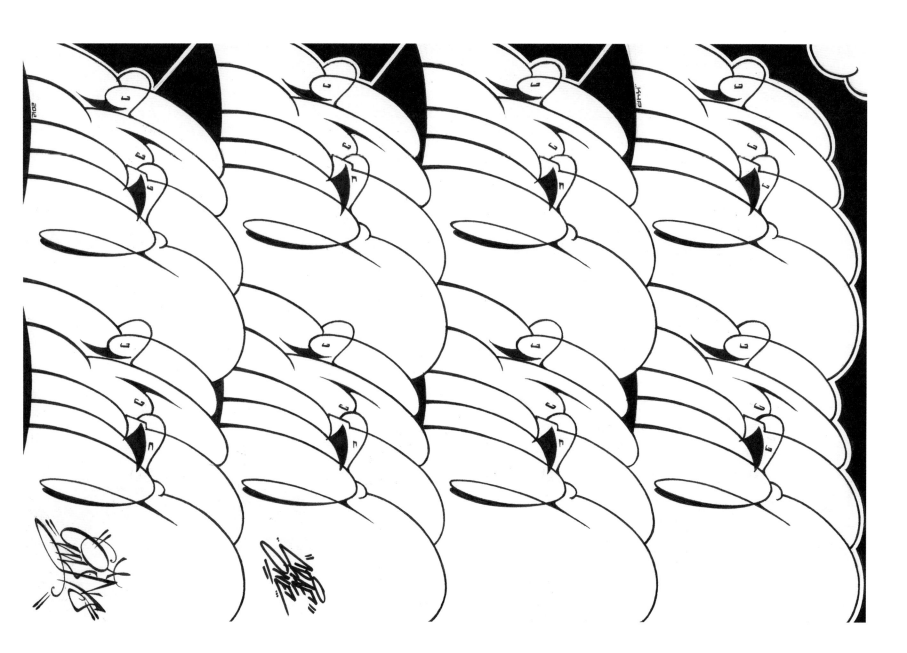

Crae and K4P

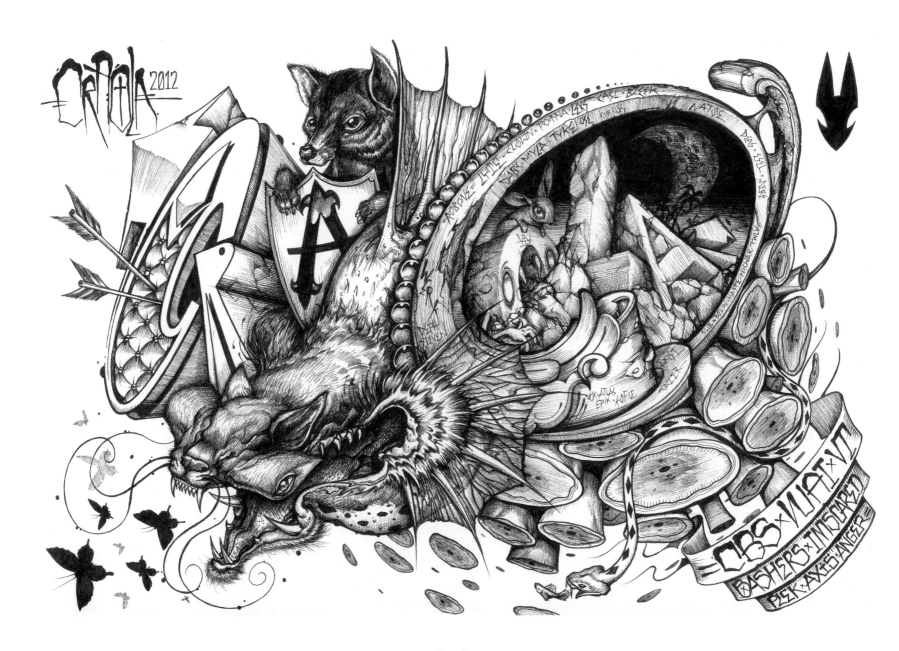

Craola

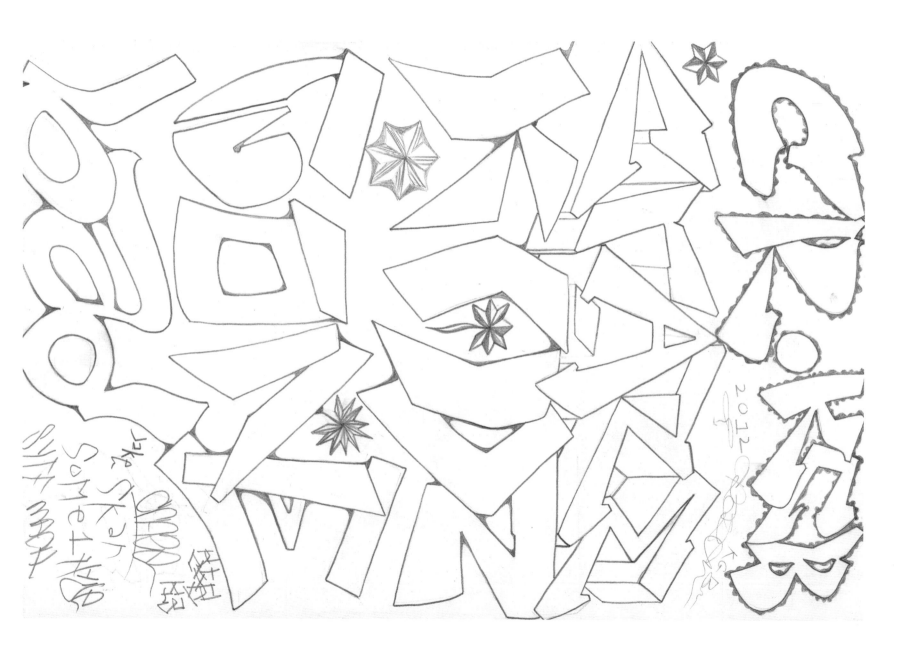

Craze

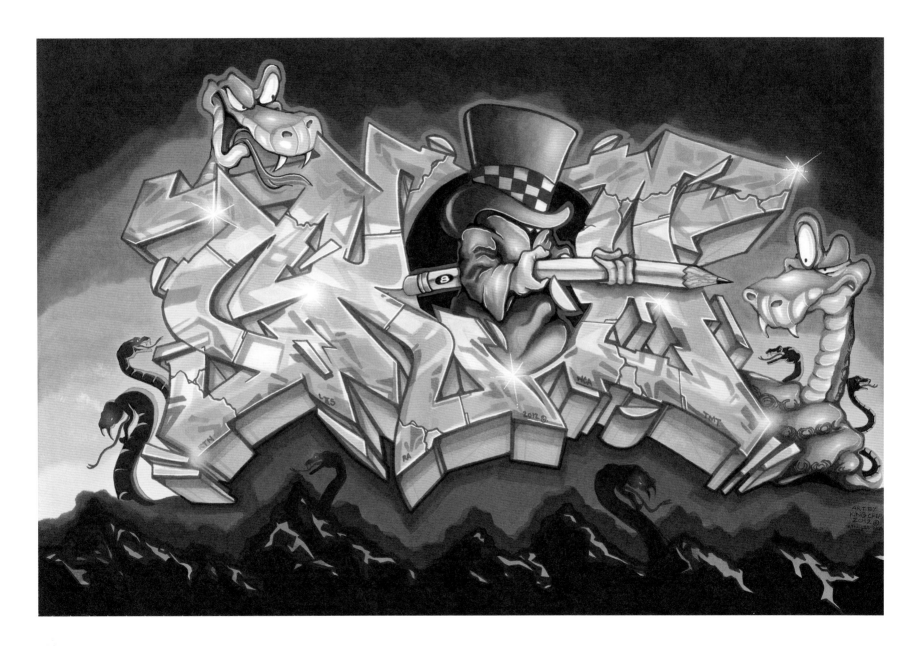

King Cre8

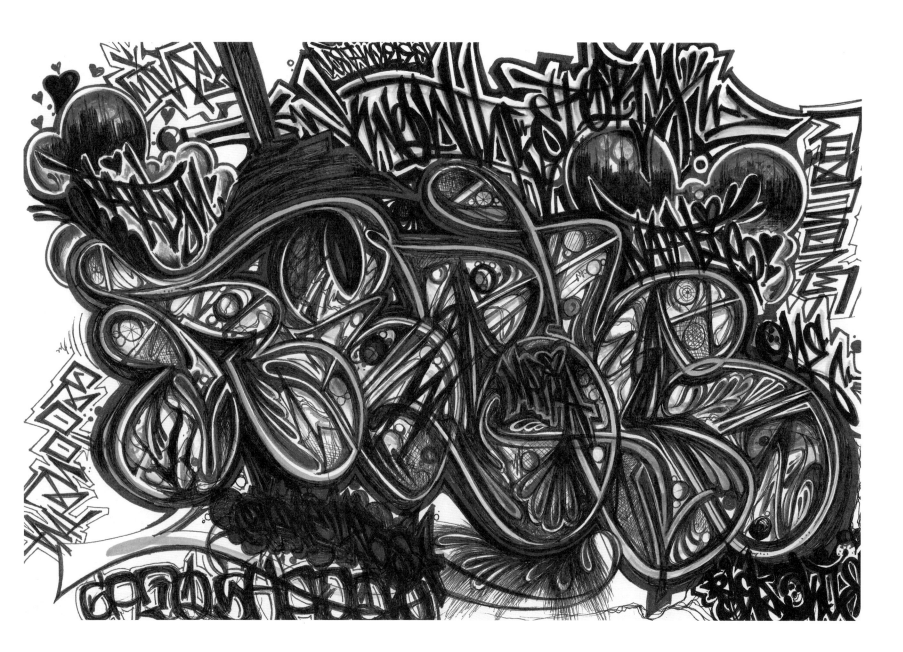

Crime (Rick One)

Cryptik

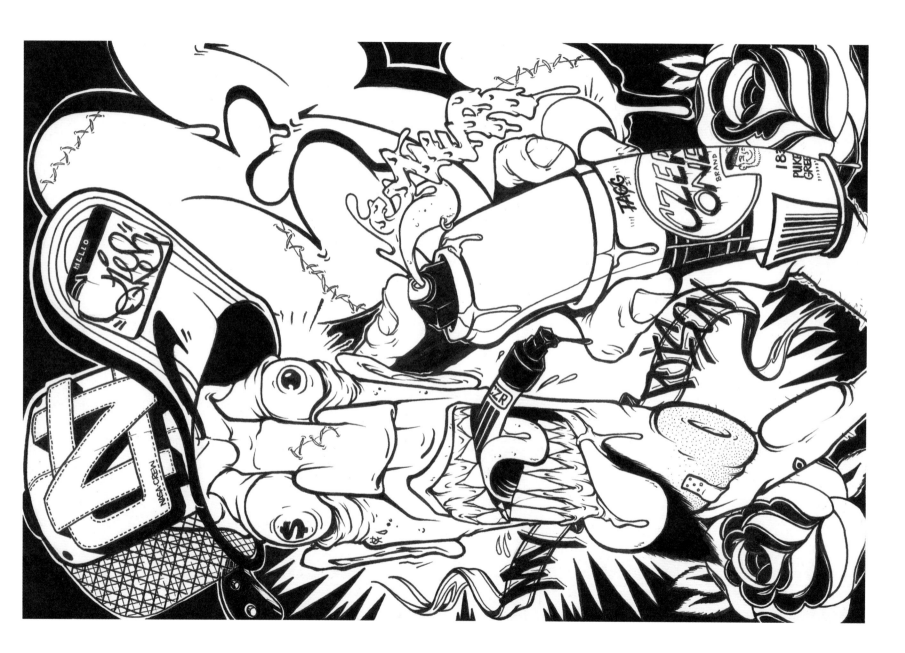

Czer One

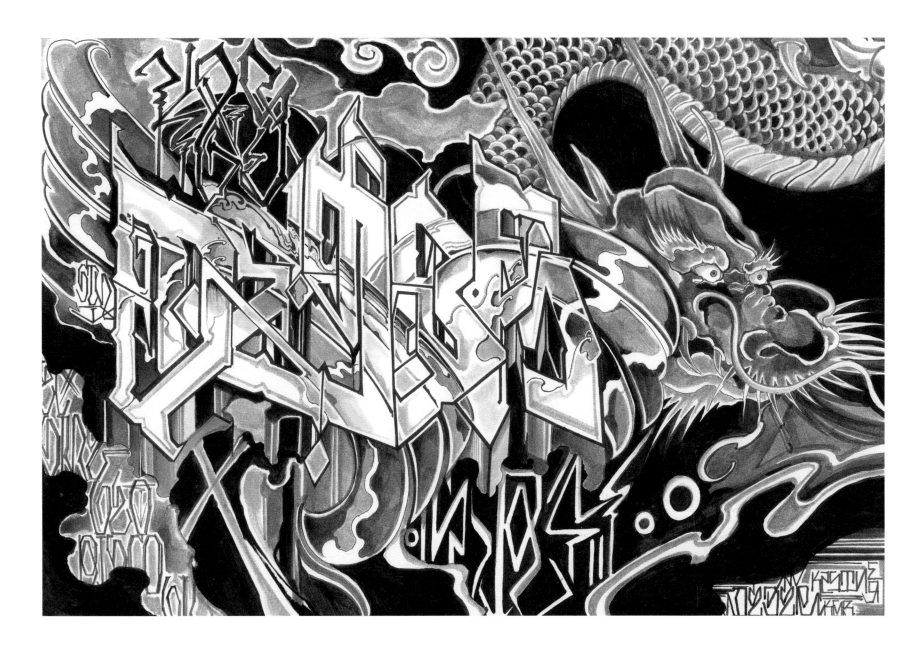

Defer

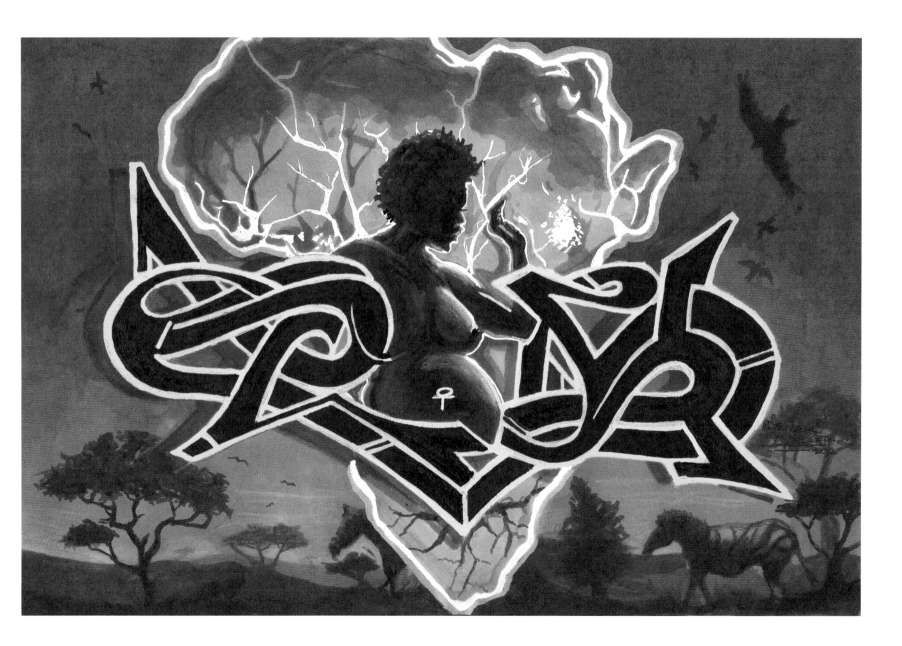

Demer One

D'MADREAMTIME

D'MADREAMTIME IS THE TIMESPAN OF MAN THAT SEEMS TA BE A LOT IN THE MIDST OF WHAT'S SO LITTLE,
QUESTIONIN' ANALYTICALLY MYSTERIOUS ENIGMAS OF RIDDLES, AS UNANSWAD CONUNDRUMS OF INSIGHTFUL SEESAYAS OF SOOTHIN'
SPOKEN TOKENS OF WHATS PURPOSELY BROKEN INTA SMOLDARIN' BITS OF JUNK FULL OF ANOTHA'S BRAZIN' BULLSHIT WIT,
THAT WHICH HAS US THINKIN' THOUGHTS TA SUBMIT TO...YET AND STILL WE FUSS AND FIGHT OVA WRONG DOIN'S
DID BY OTHAS POINTIN' FINGAS THAT LINGA AT ONE ANOTHA ... SAYIN' THAT'S NOT MY BROTHA OR SISTA ... BUT
STILL OUT THERE WASTIN' EVEN MORE OF WHAT WE'RE GIVEN THAT ONE CHERISHES OH SO LITTLE ,,, TAKIN'
WHAT'S PLANTED FOR GRANTED, WHILE LOOKIN' AT LIFE FROM A VIEW THAT'S SLANTED IN THE FORM OF WARPED
SENSES THAT COMMENCE'S TA OBSCURE ANY AND EVERYTHIN' THAT'S PURE SEEKIN' A CURE JUST SO ALL CAN ENDURE...

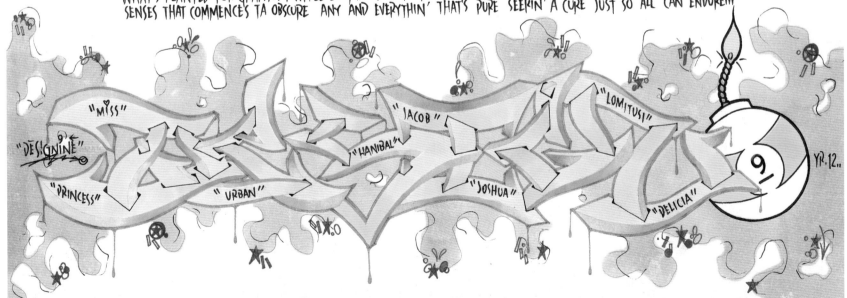

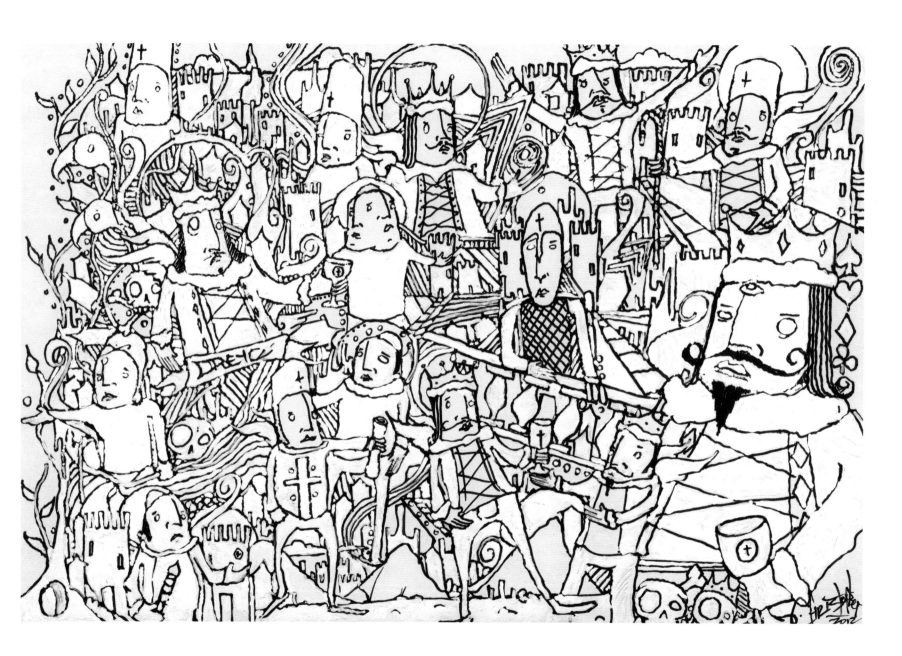

Dr. Eye

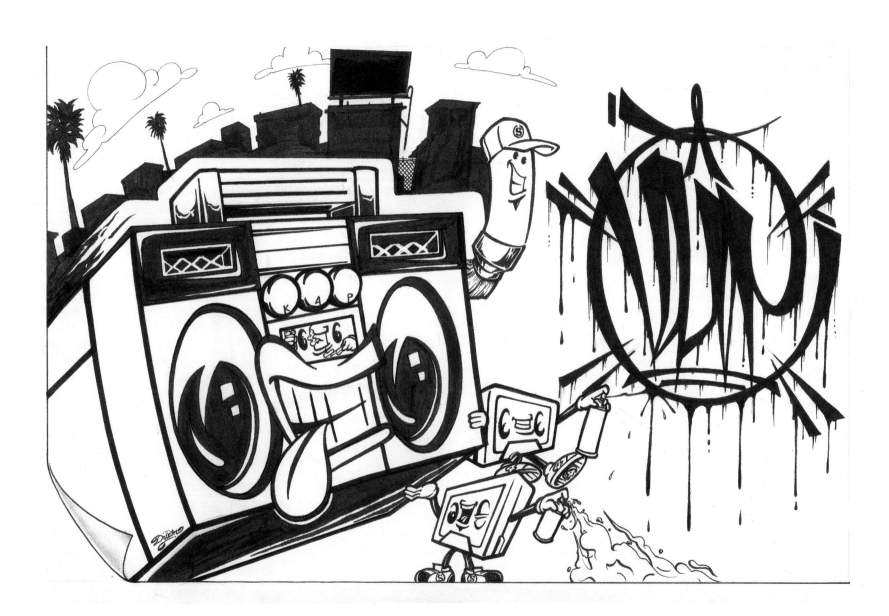

Duem and Crae

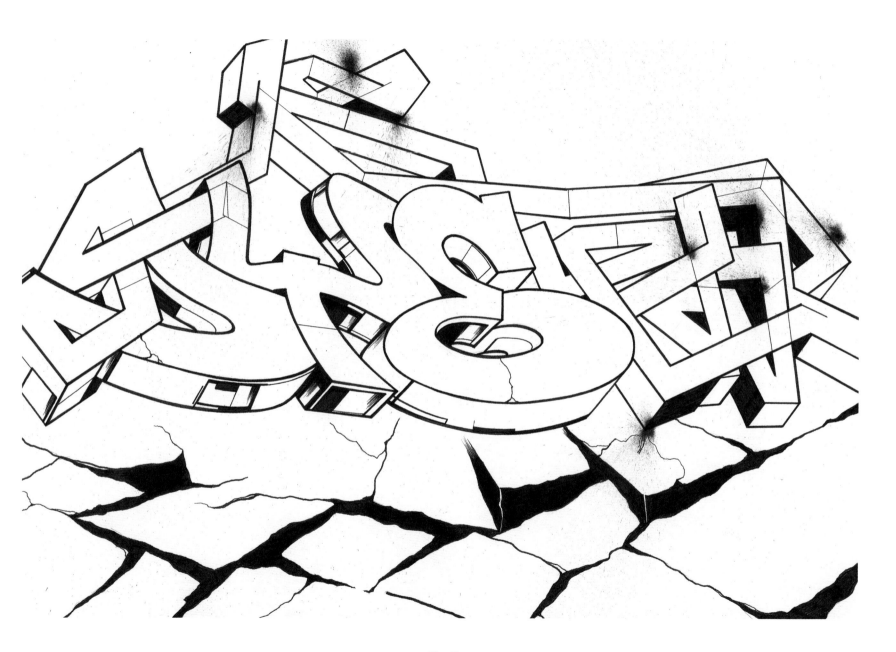

Dye5

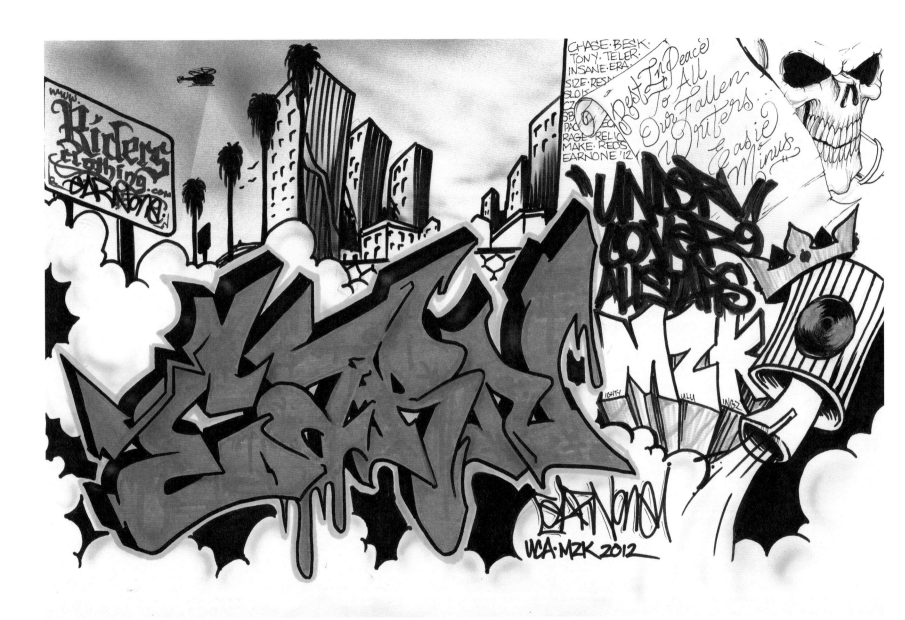

Earn One

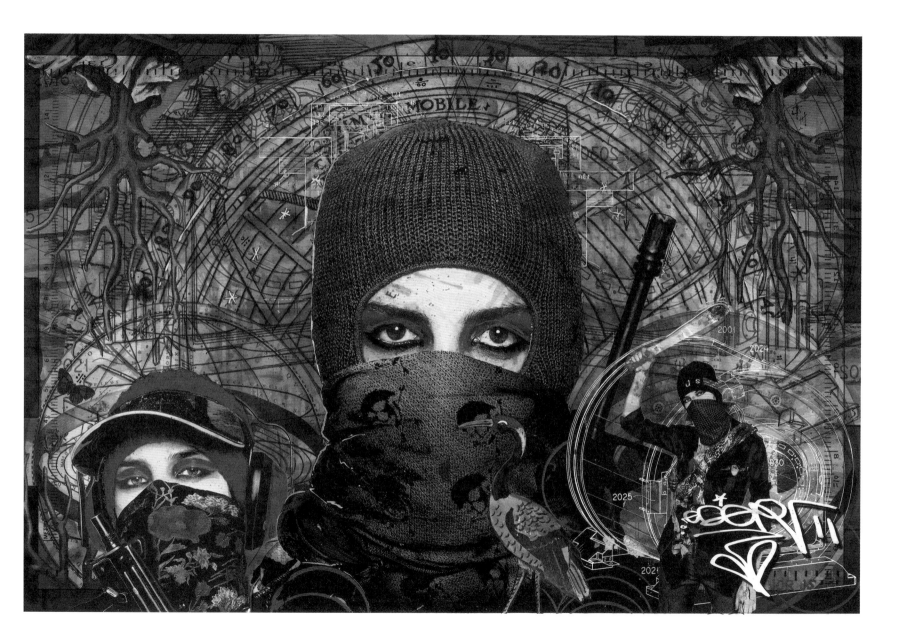

Eder

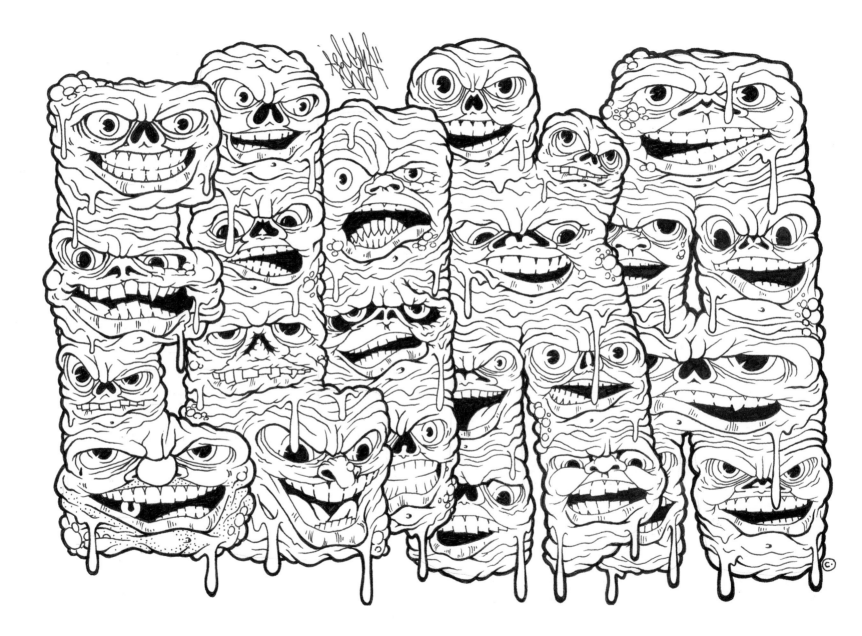

Elika

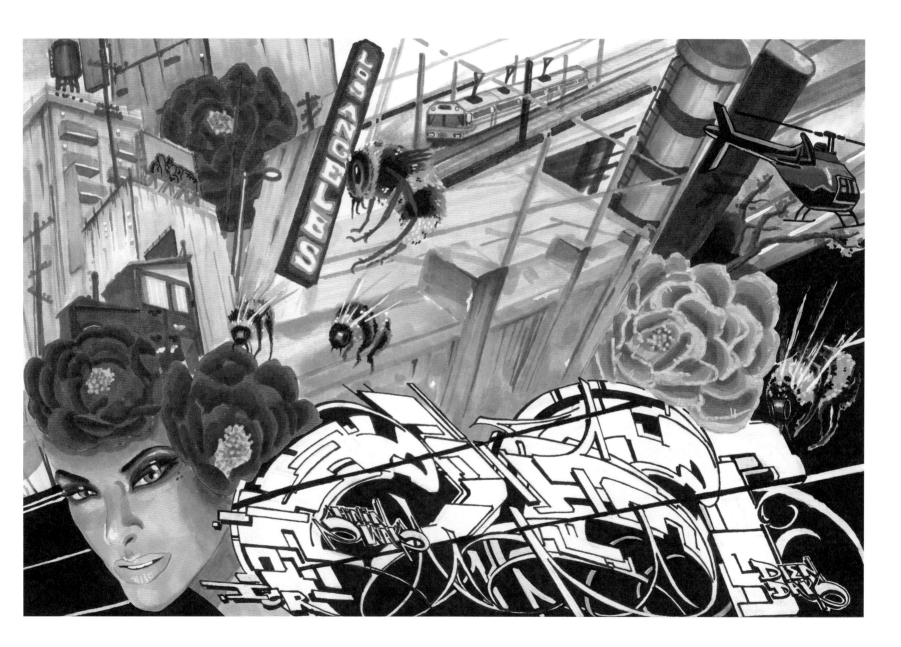

Else (front)

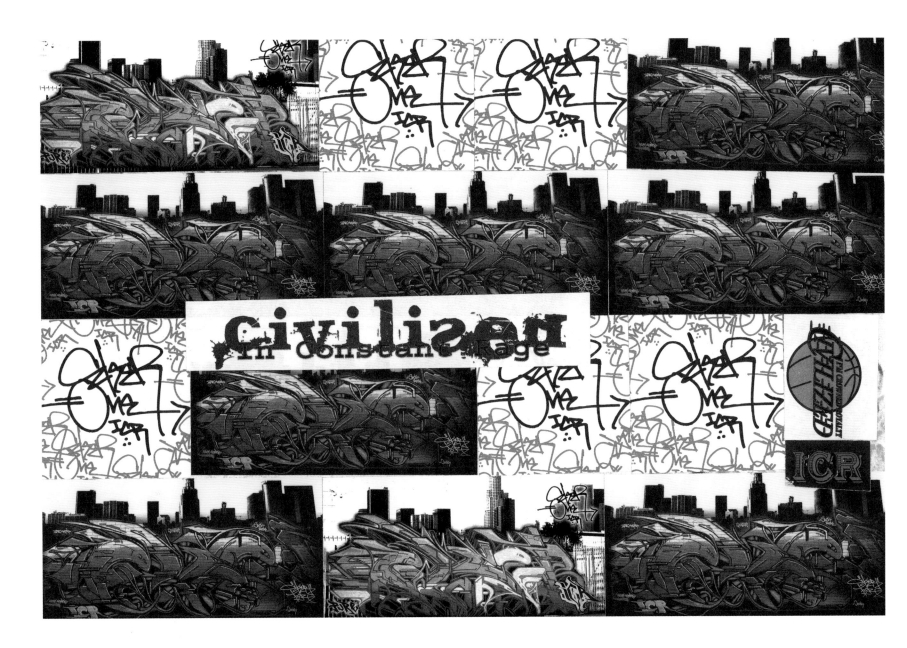

Else (back)

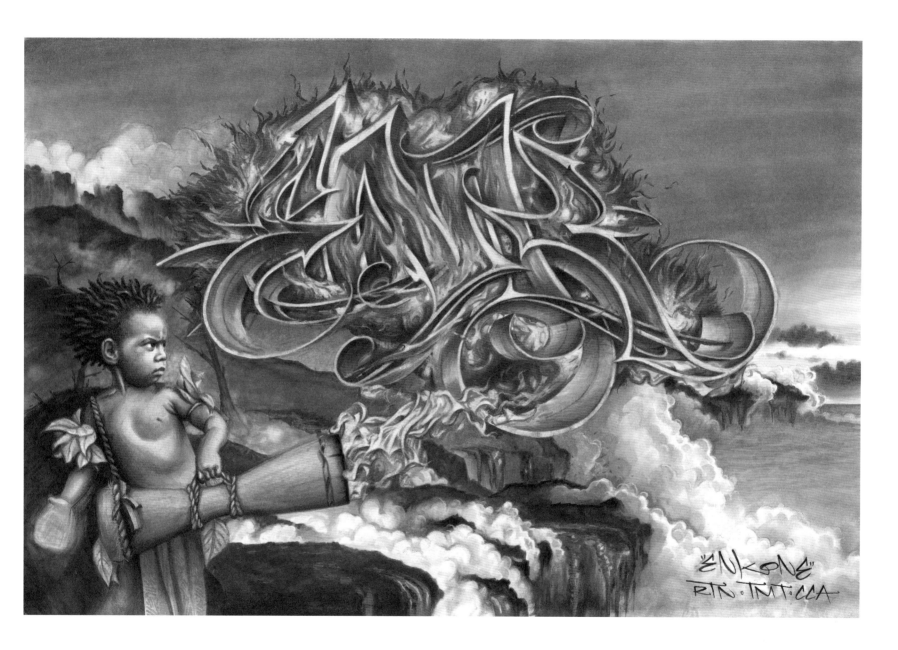

Enk One

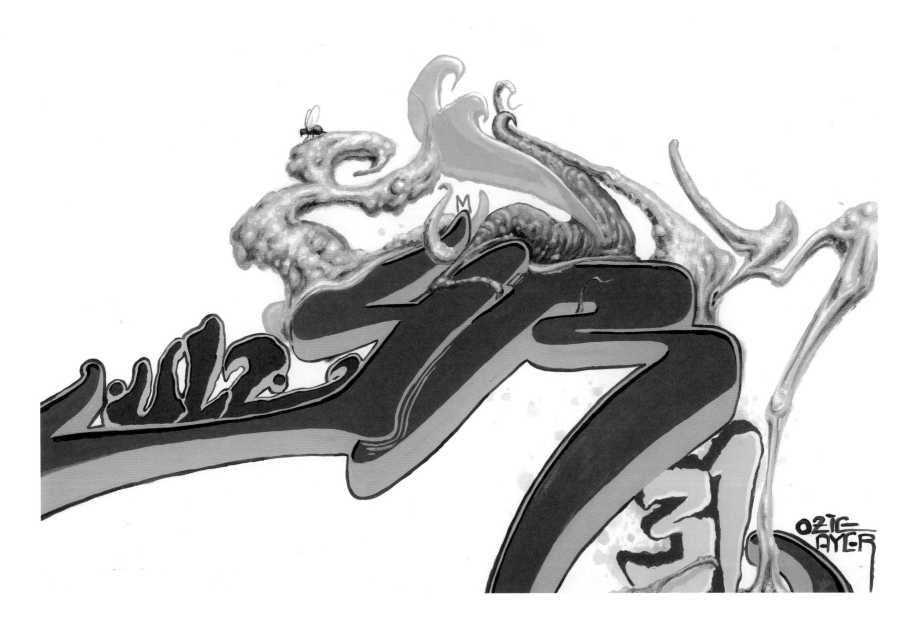

ESK31

THIS GUY DROVE UP IN HIS CADILLAC WITH HIS GIRL ONE LATE AFTERNOON. TRICEZ, SABER MYSELF AND A FEW OTHER WERS OUTSIDE TALKING. WE SEEN HE HAD A L'L SPRAY ON IT ALREADY SO WE ASKED IF WE COULD HOOK UP THE REST OF IT. HE SAID "GO FOR IT"

"CUSTOM PAINTED CADDY" SKID ROW LOS ANGELES

Estevan Oriol

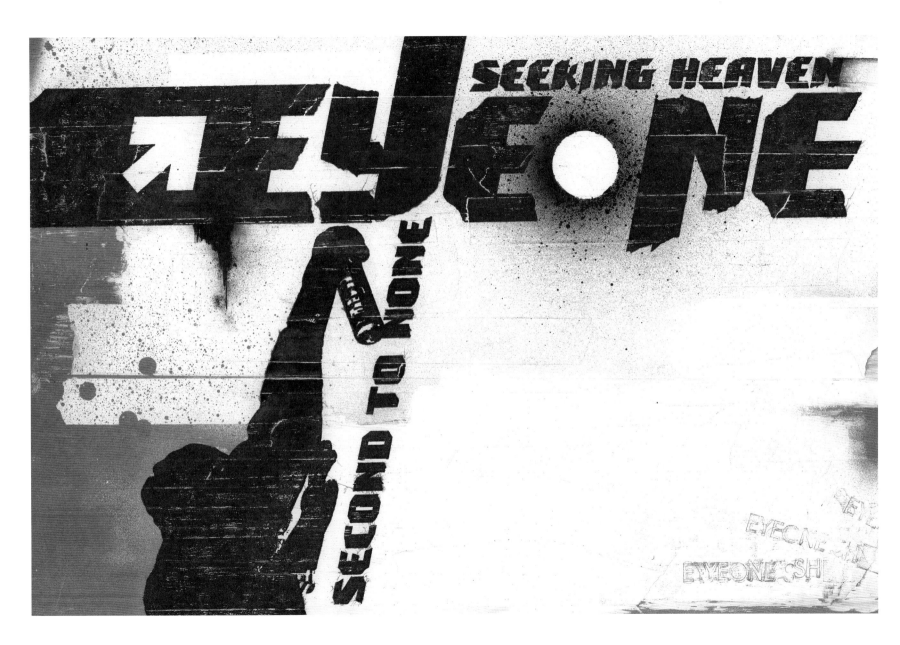

EyeOne (front)

EyeOne (back)

Fearo

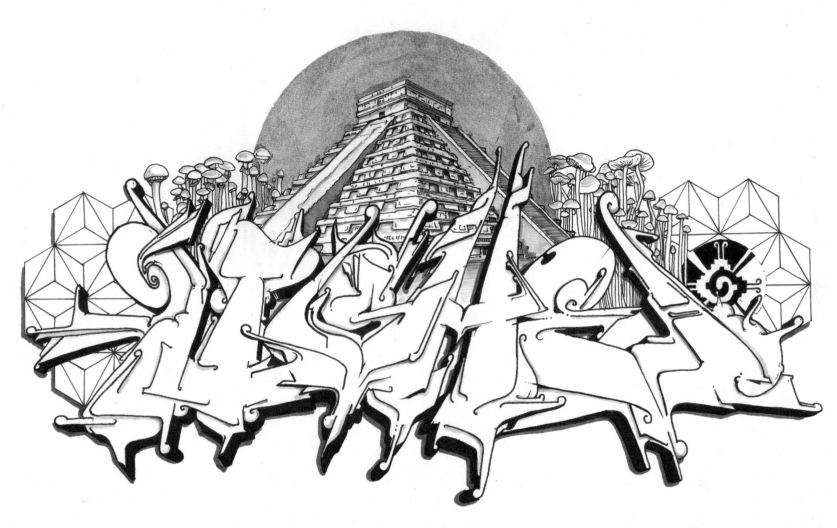

Fishe (front)

Fishe (back)

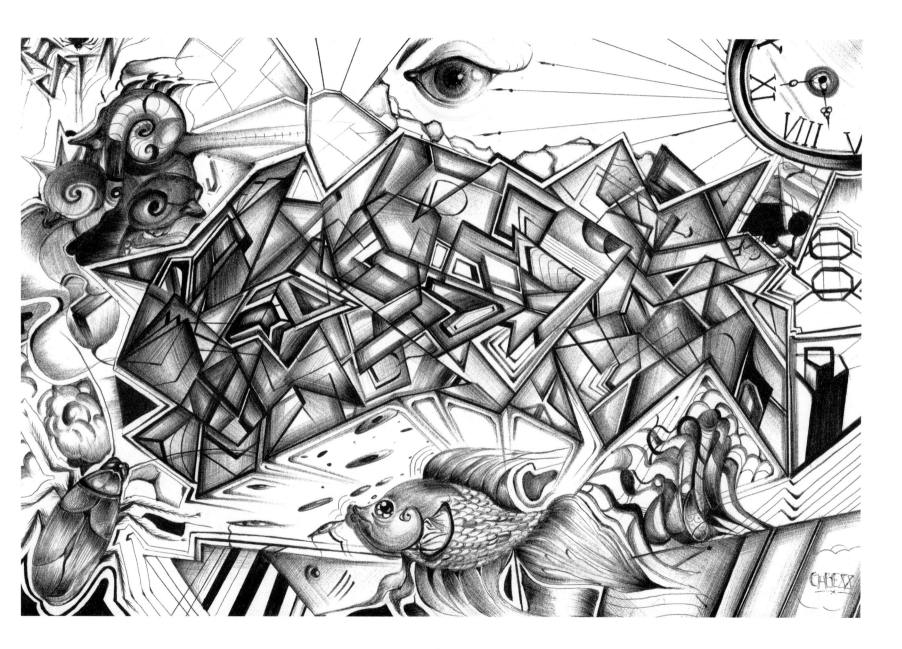

Gabe88

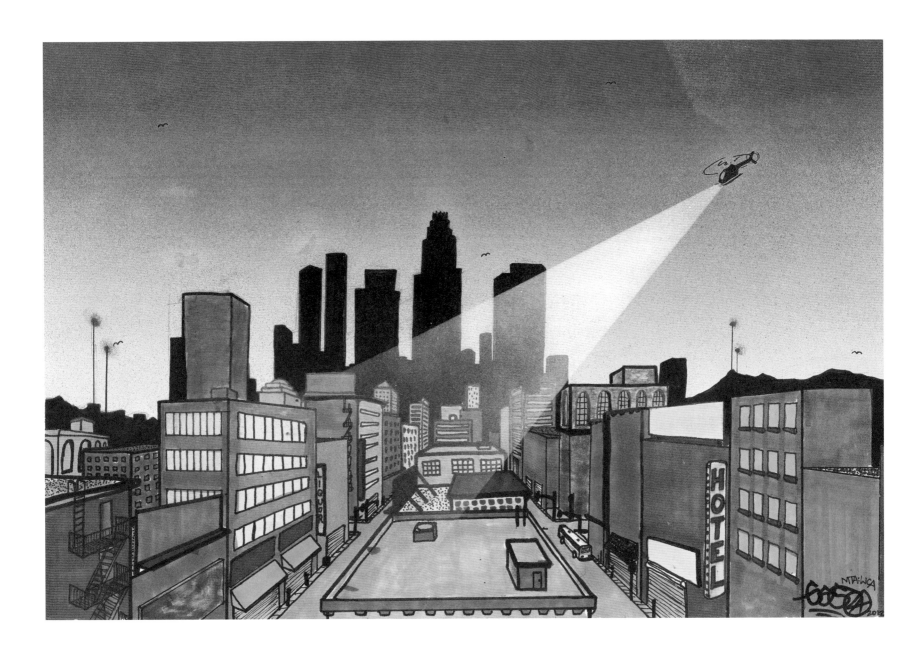

Gasoline

Gkae

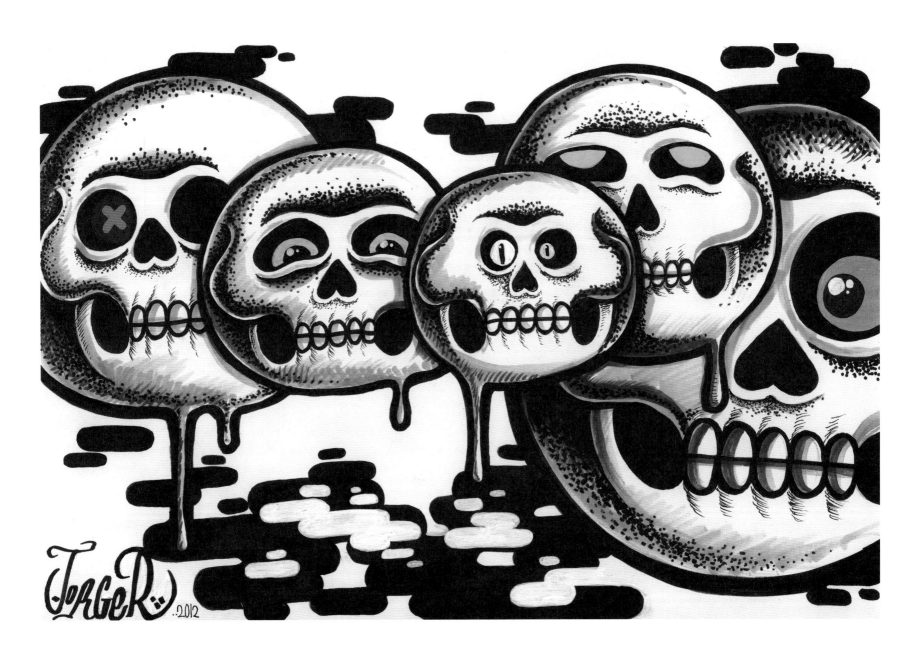

Gorgs

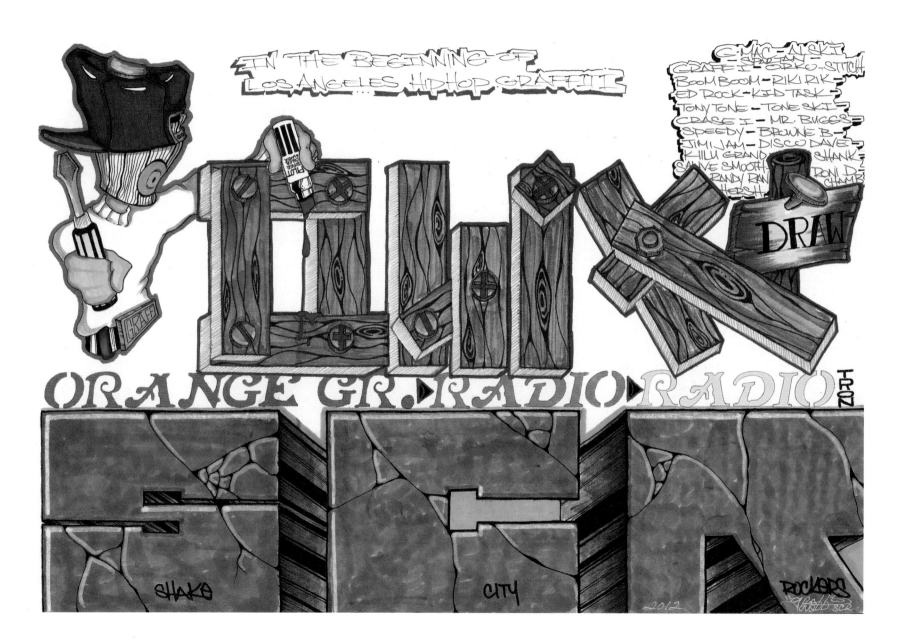

Graff One

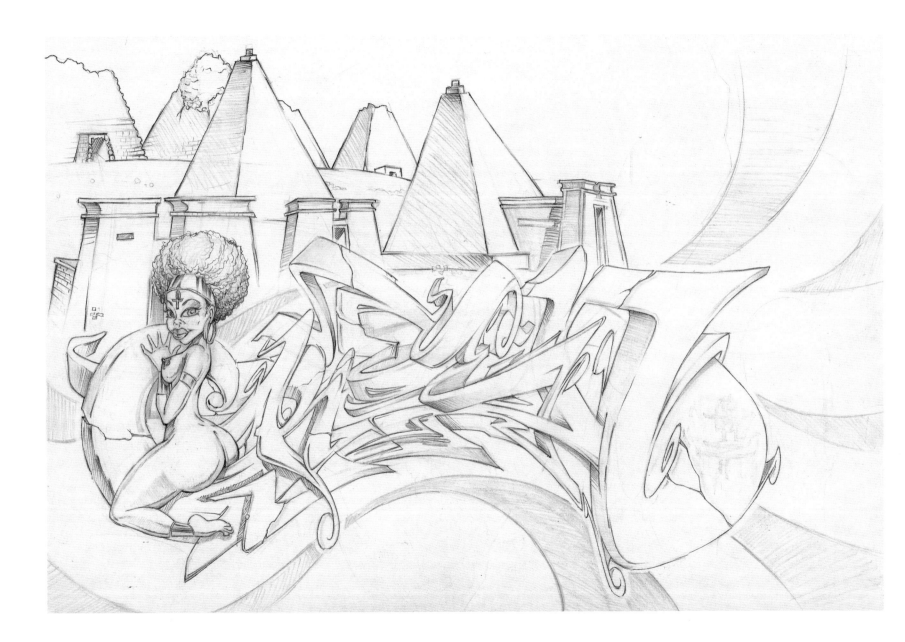

Green

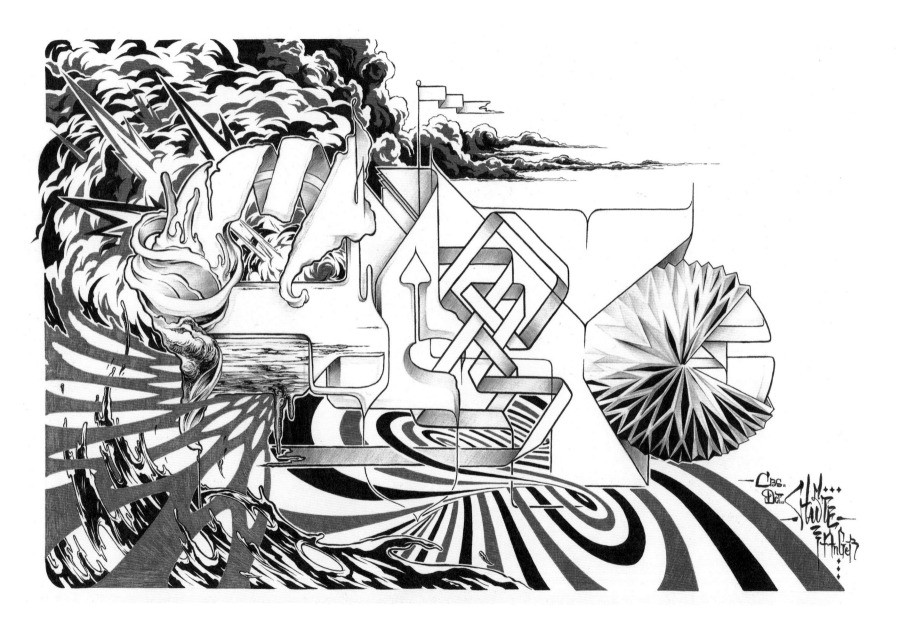

Haste

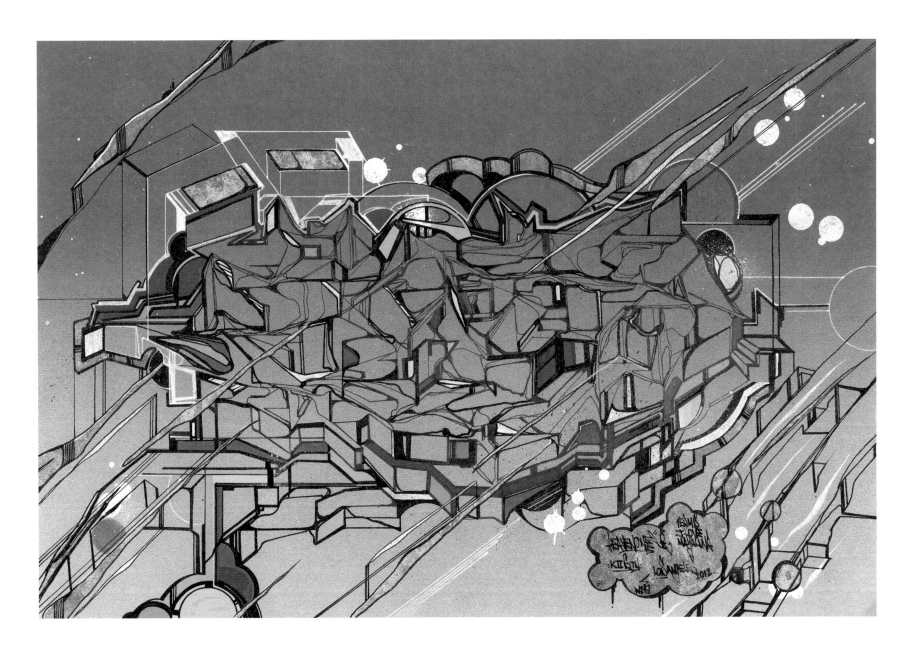

Heaven

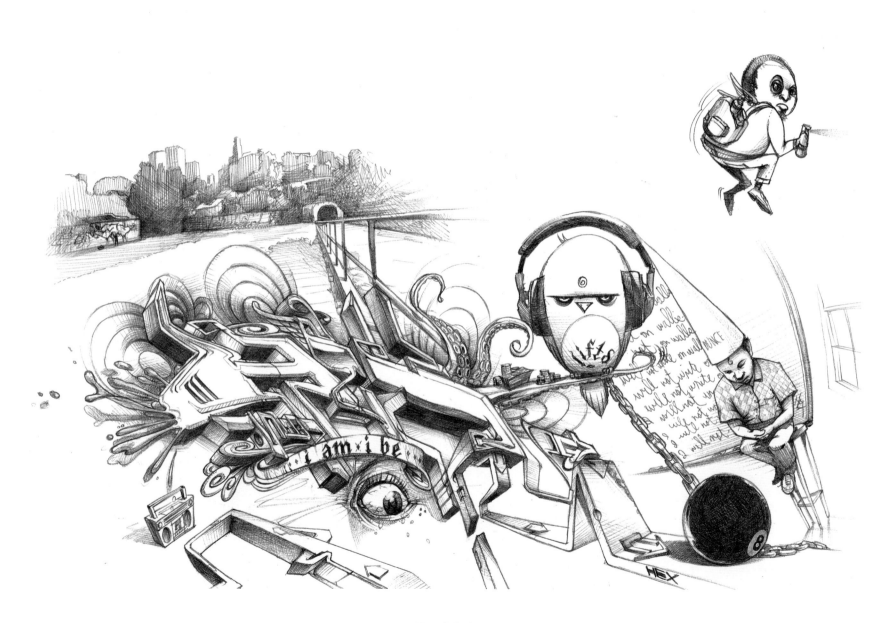

Hex (LOD)

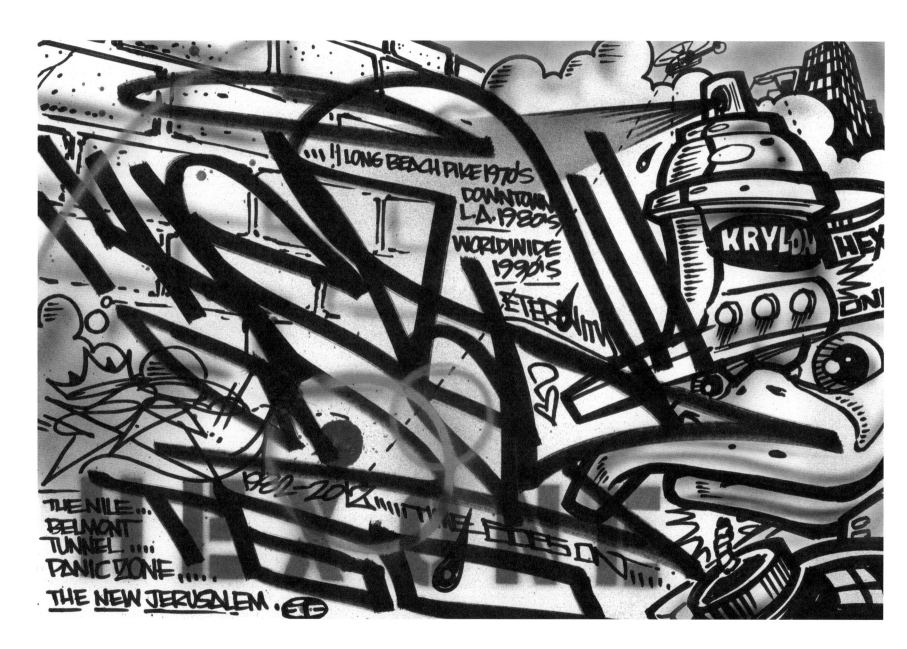

Hex One (TGO)

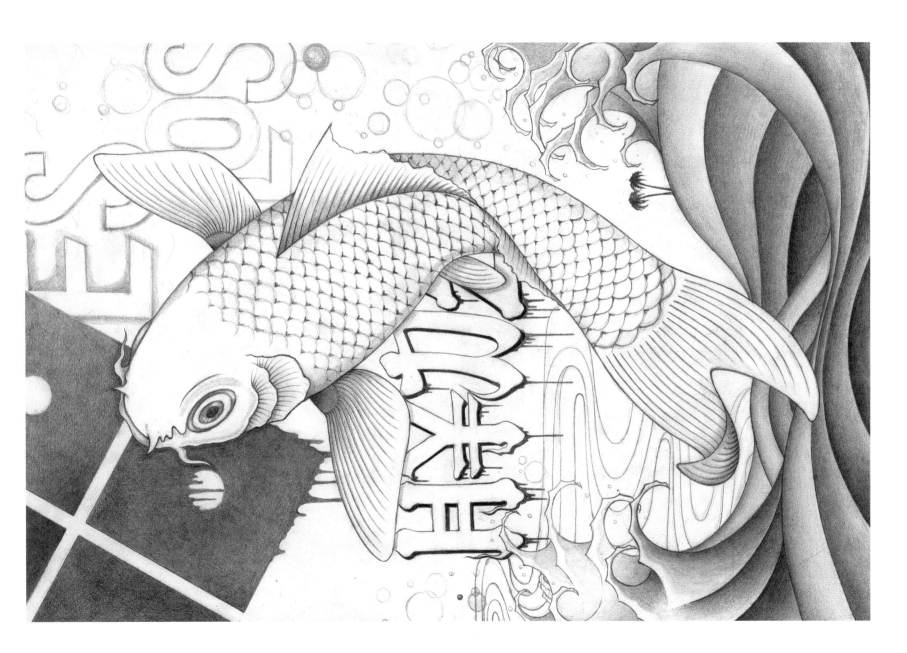

Hyde

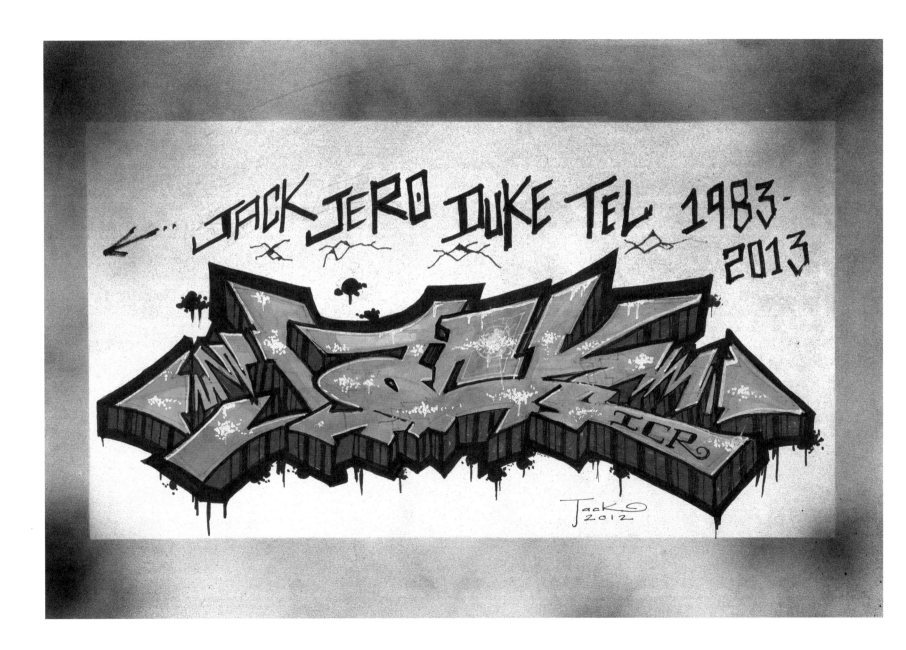

Jack

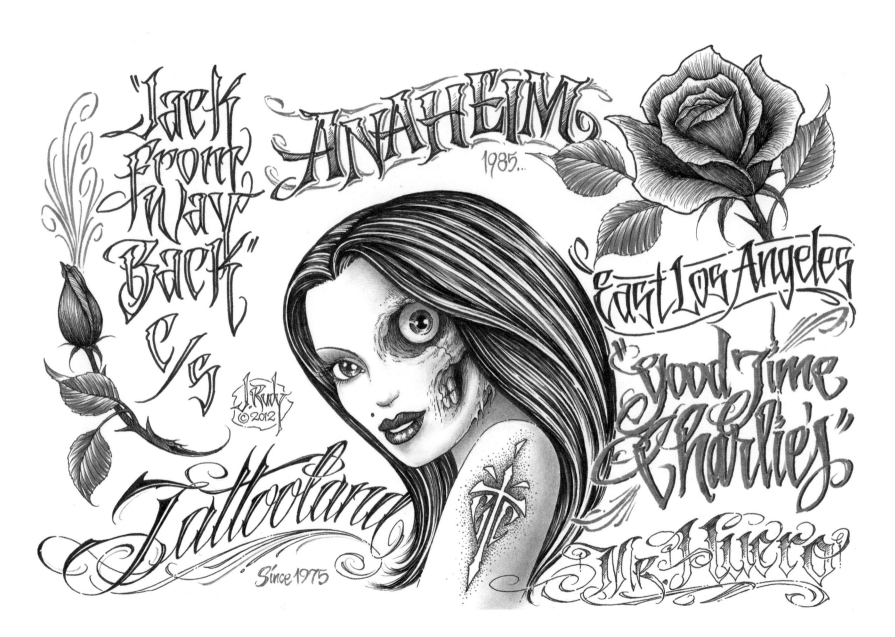

Jack Rudy (Mr. Huero)

Jake One

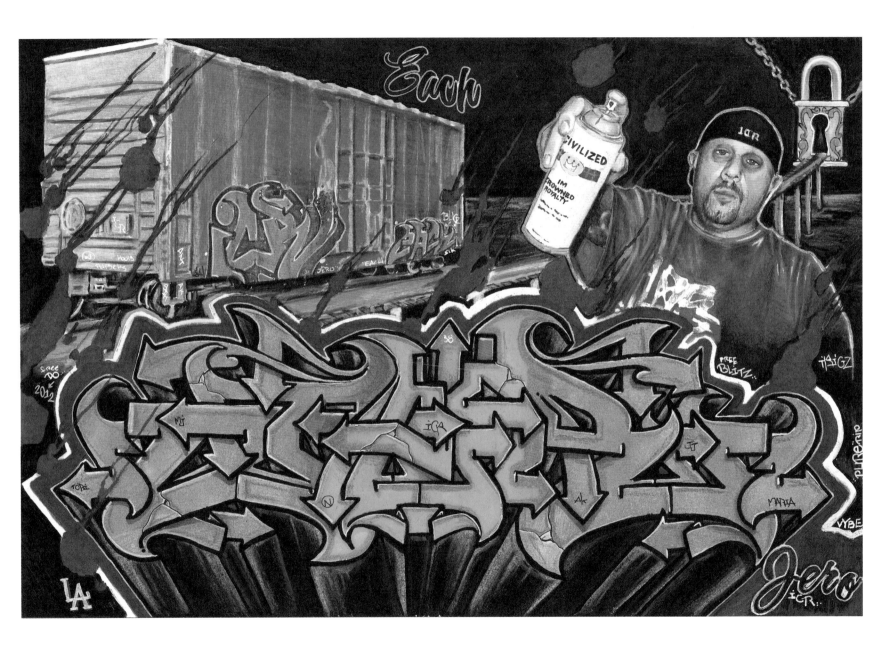

Jero and Each (front)

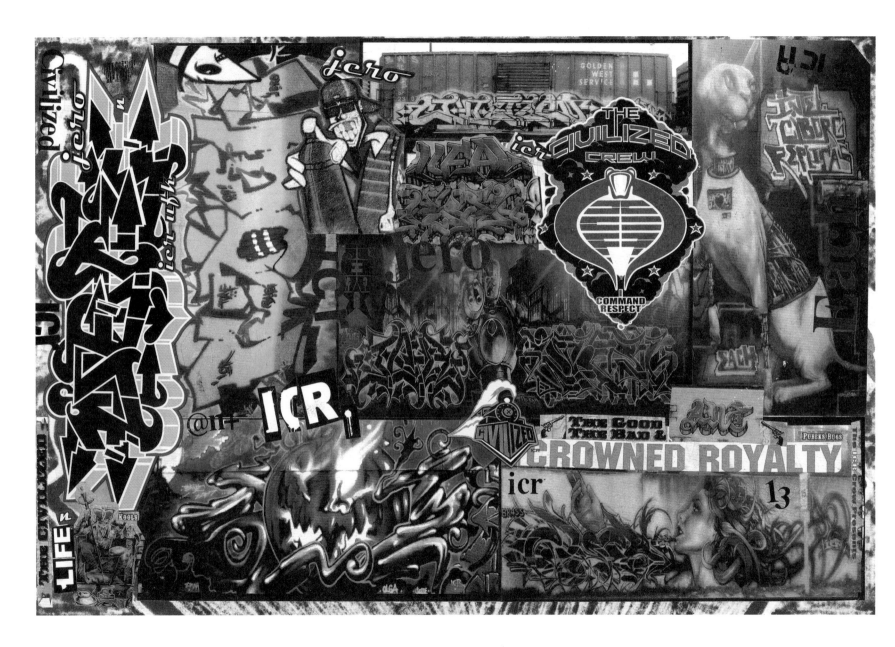

Jero and Each (back)

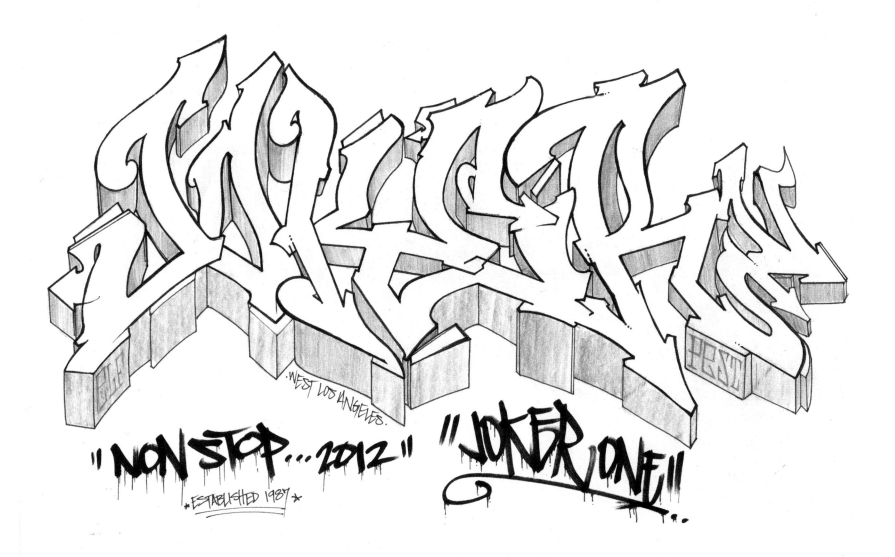

Joker One

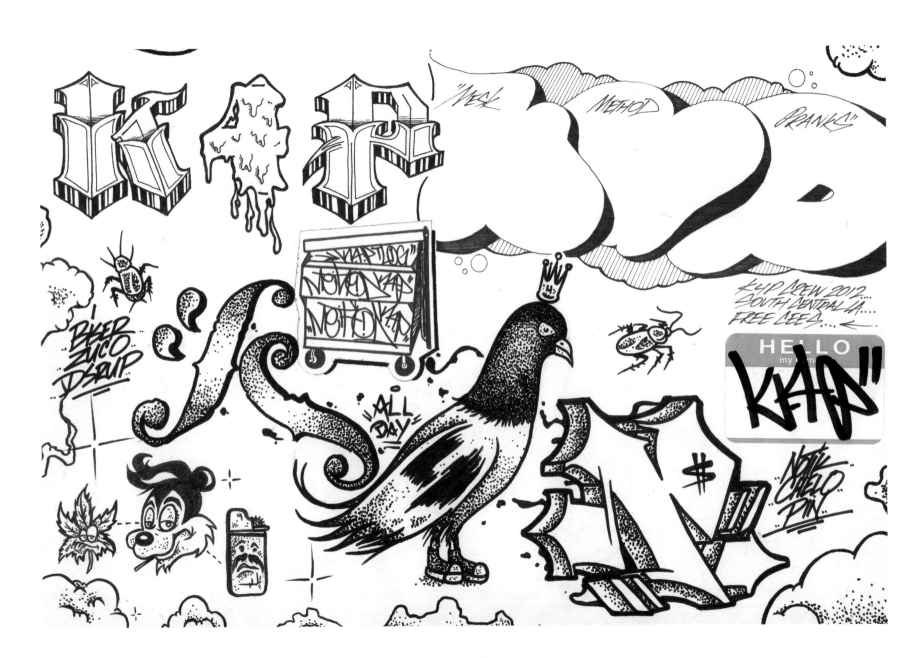

K4P (Pranks, Method, Biser, Crae, Dsrup)

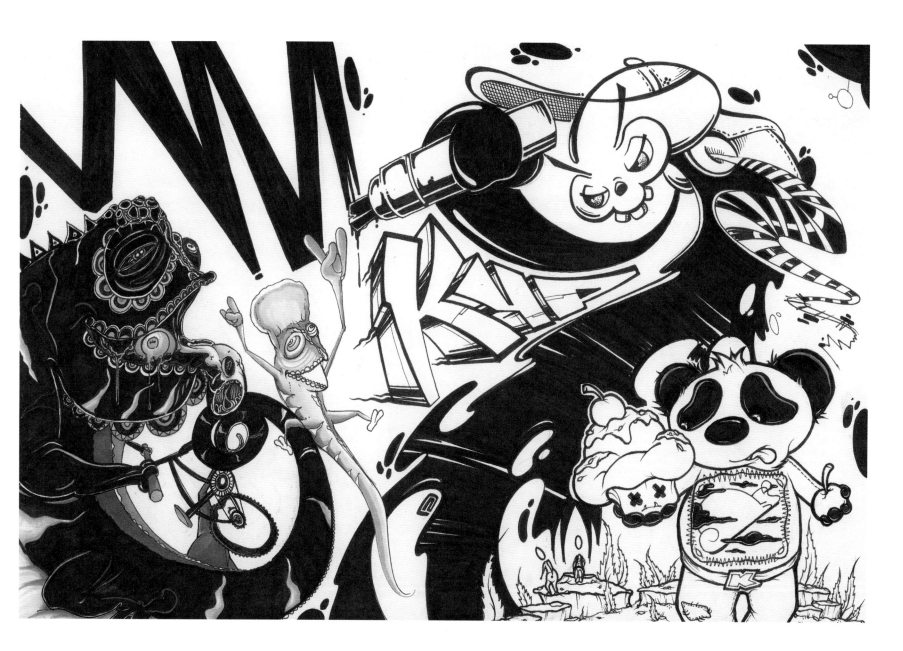

K4P (Chelo, Noek, Notik)

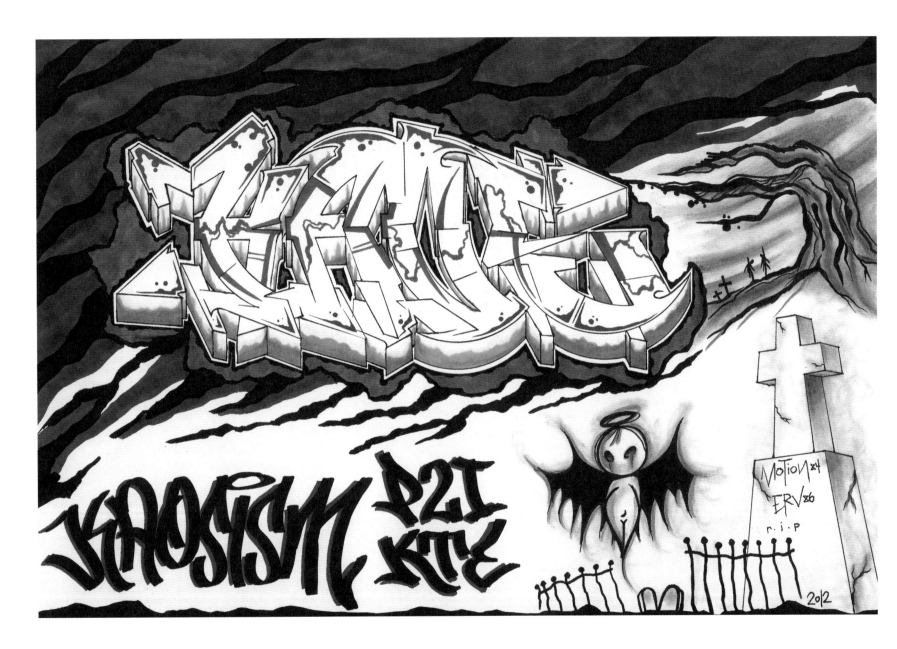

Kaos

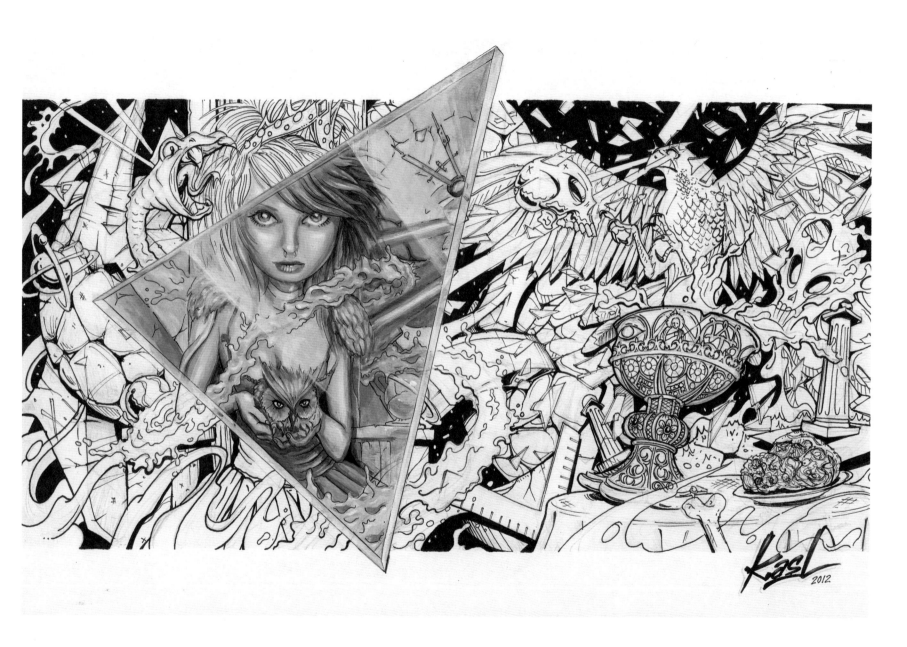

Kasl

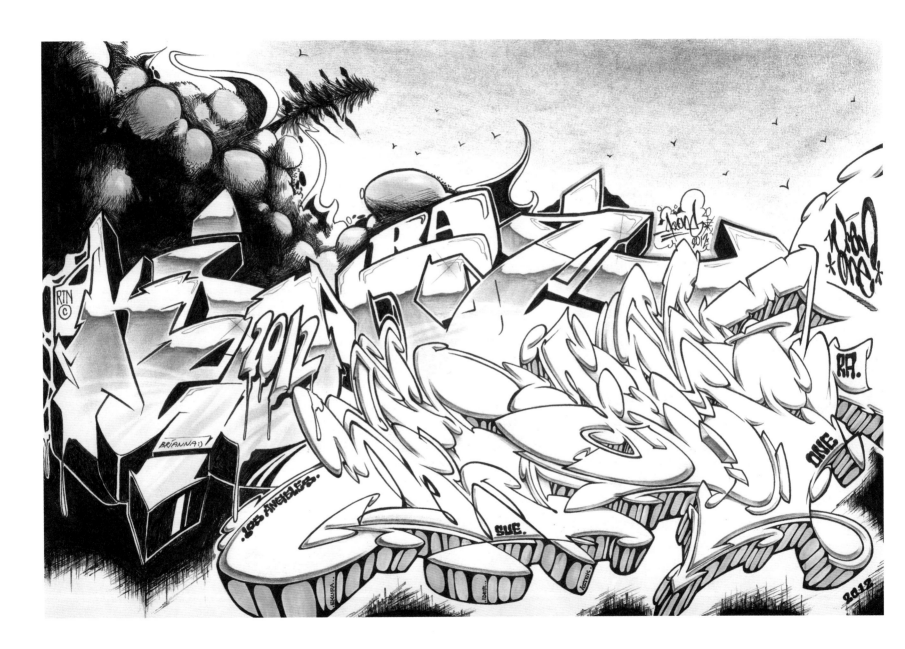

Keo One and Wram One

Kofie

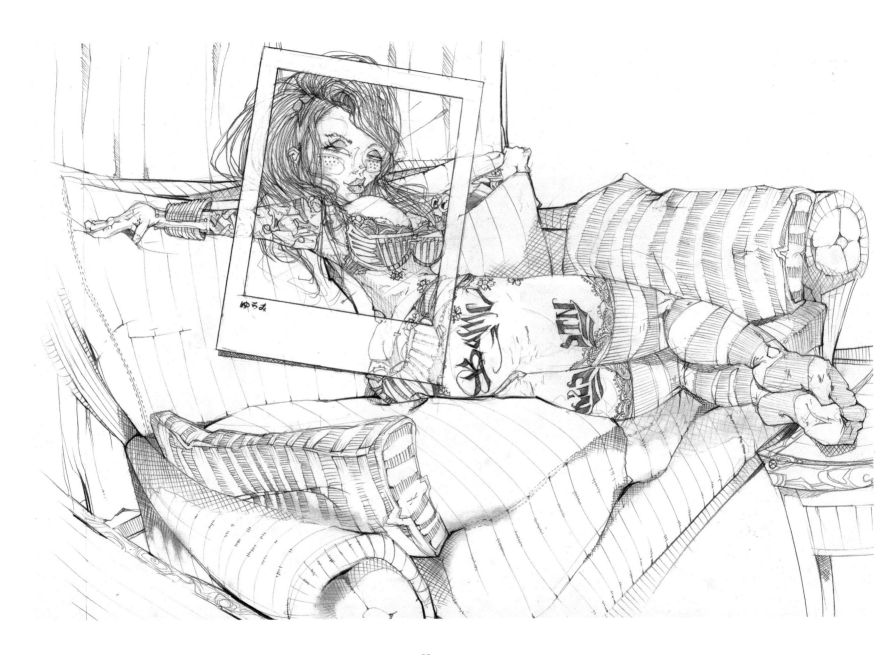

Kopyeson

Kost One

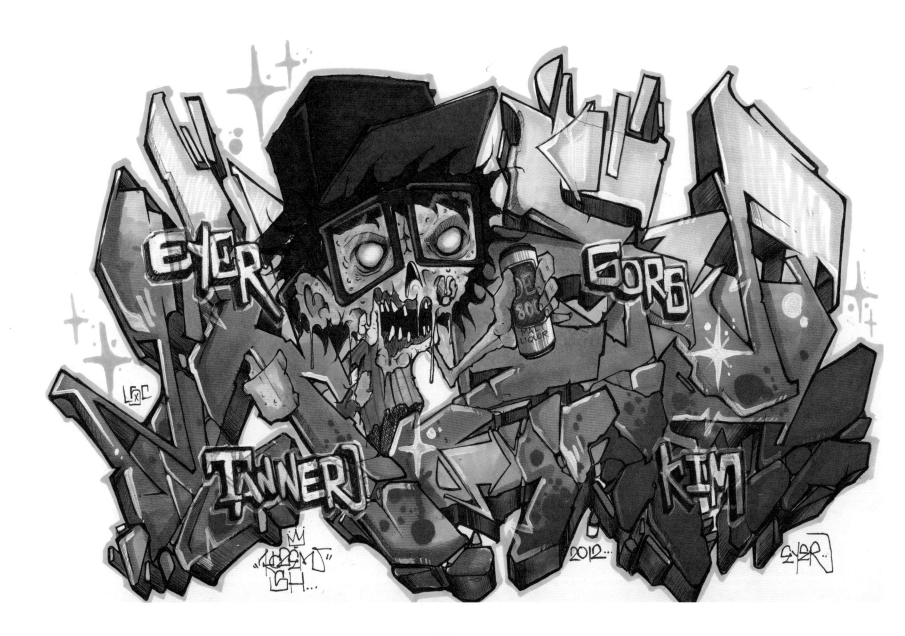

Kozem

Krenz (Yem)

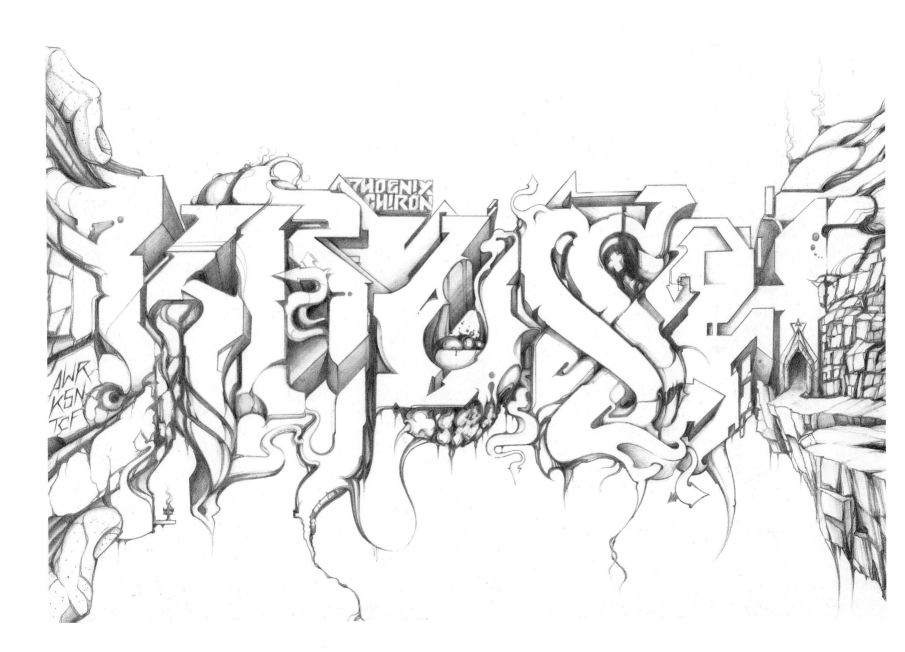

Krush

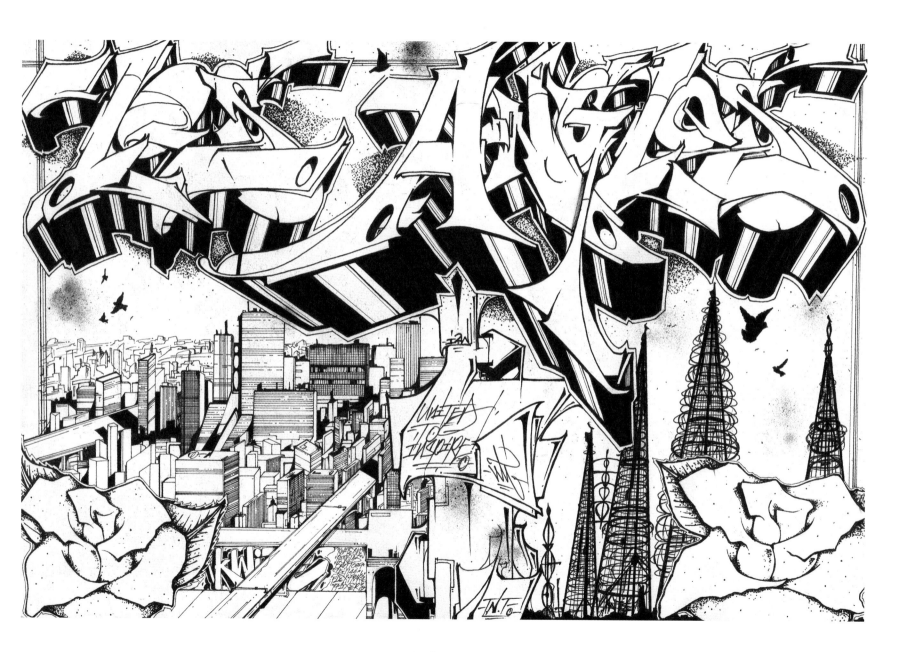

Kwite One

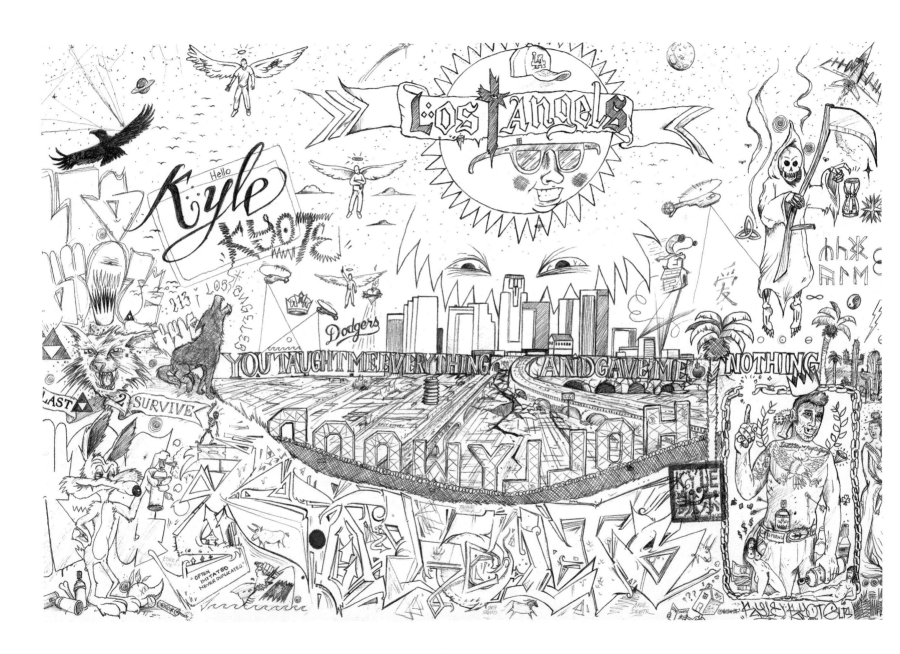

Kyle Kyote

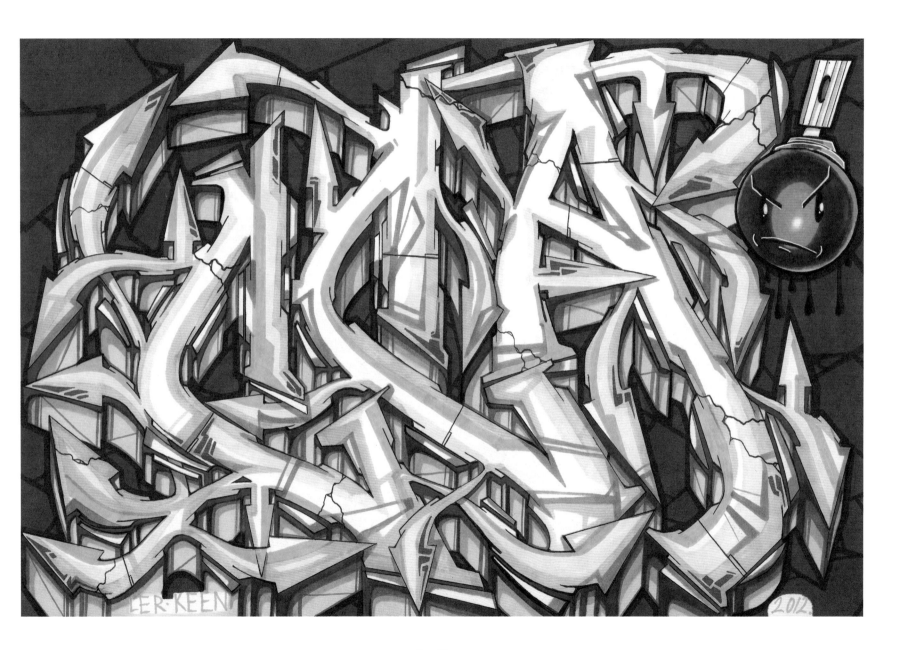

Ler Keen

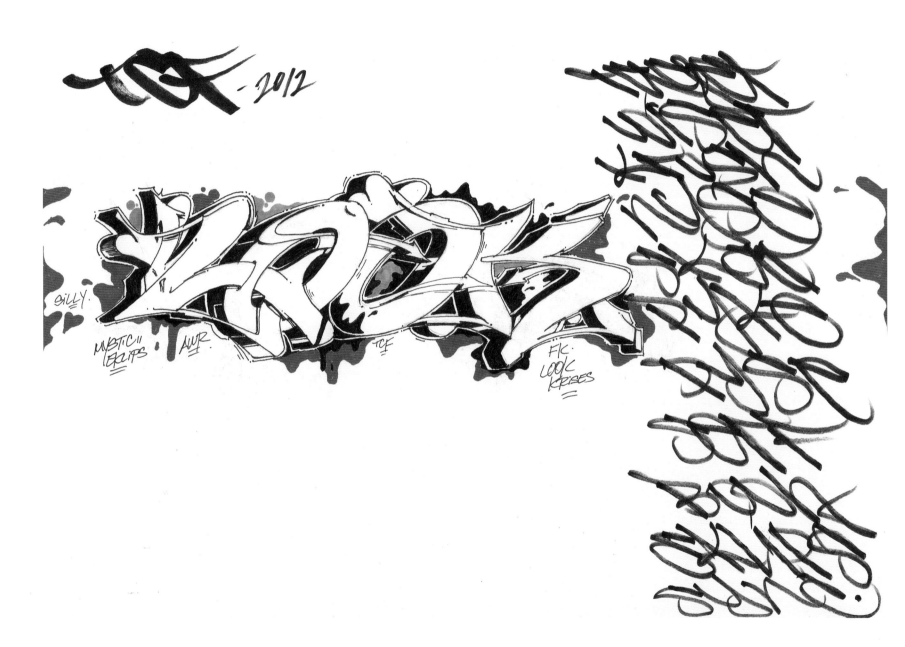

Look

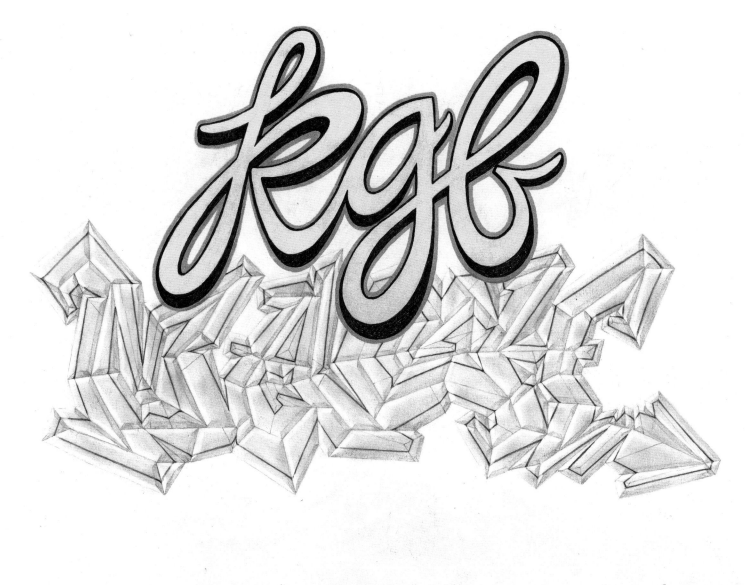

"MACH" KGB 2012

Mach Five

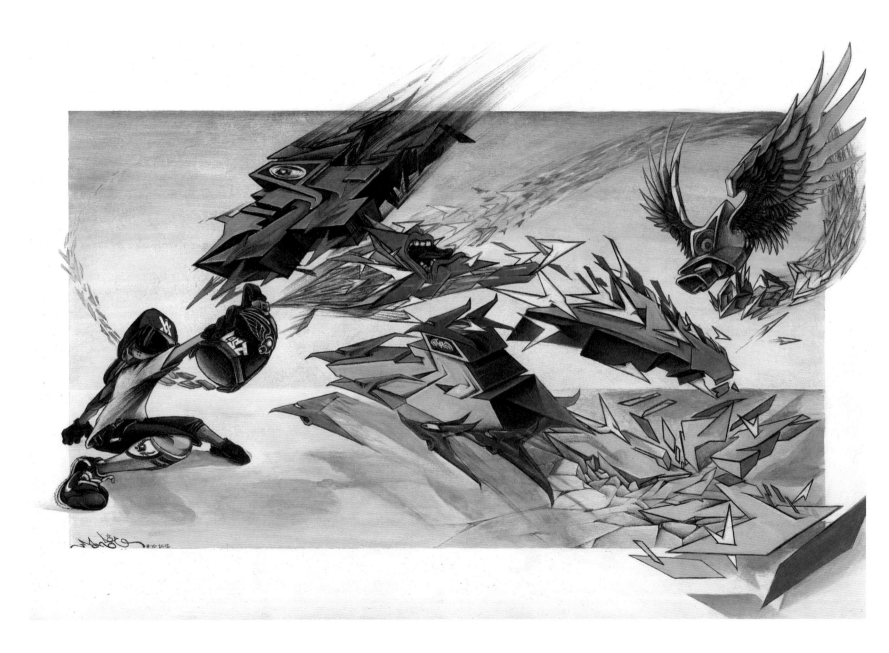

Mandoe

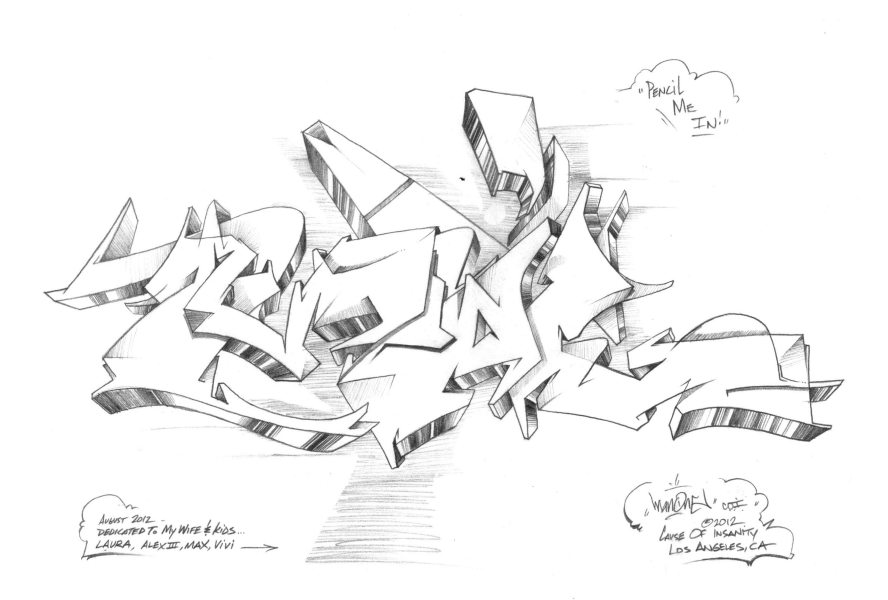

Man One

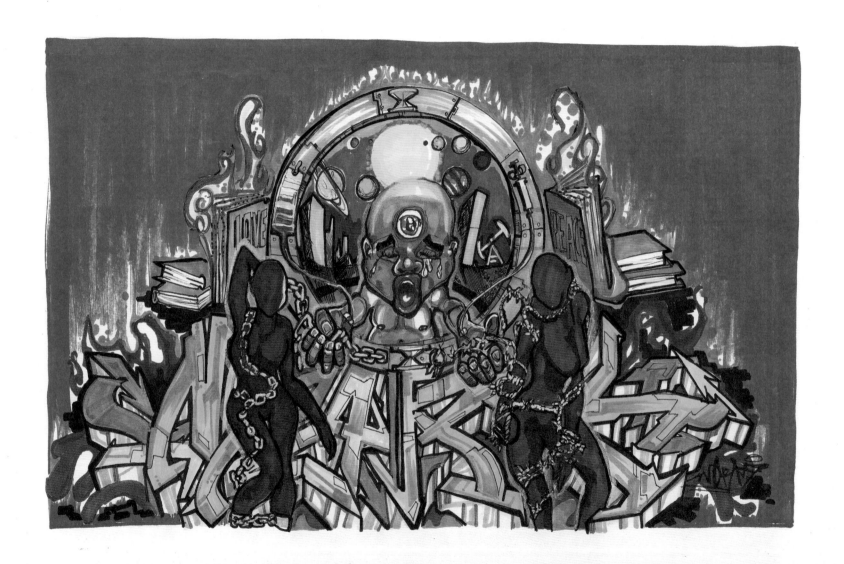

Mark7

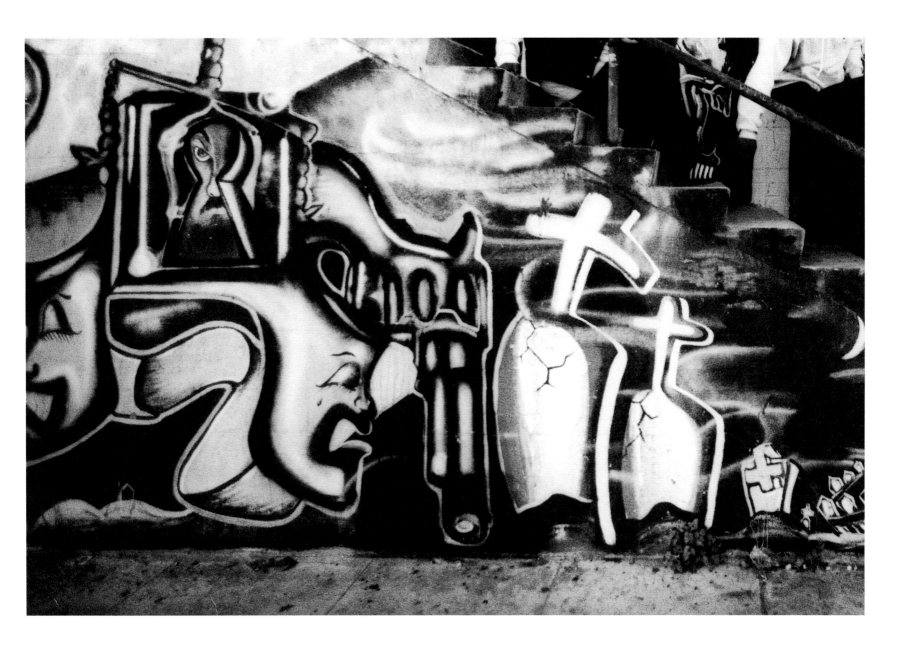

Mike Miller

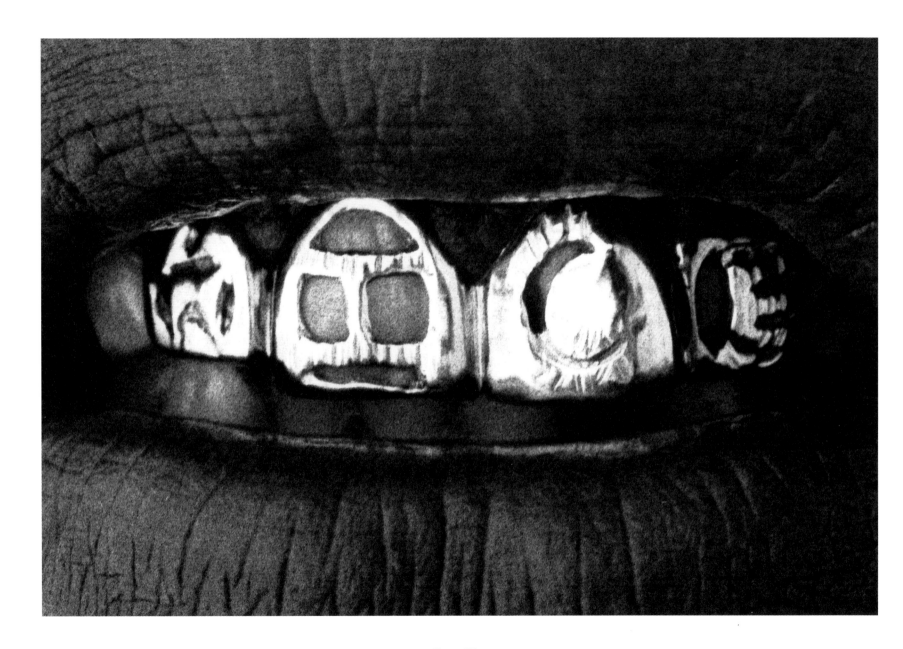

Mike Miller

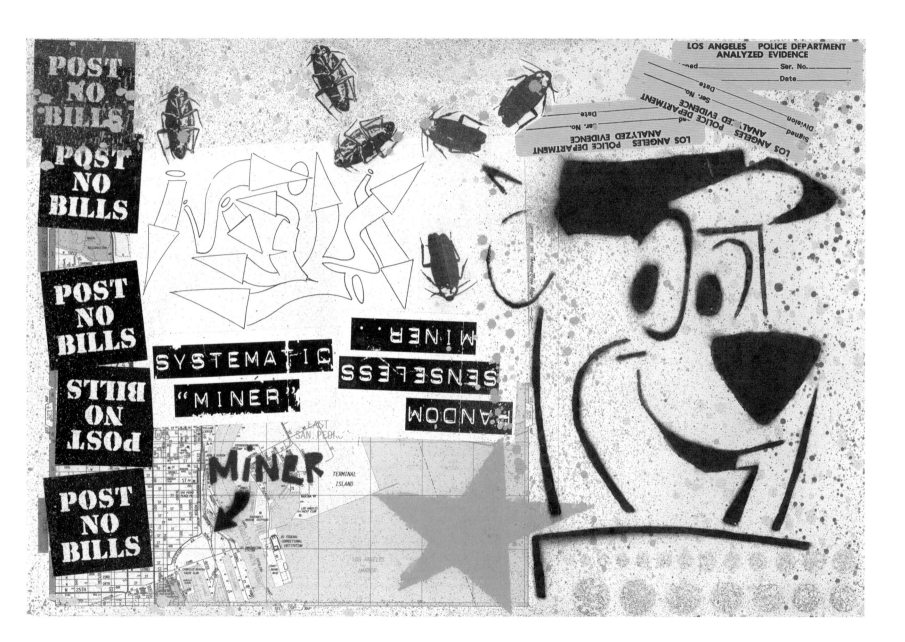

Miner

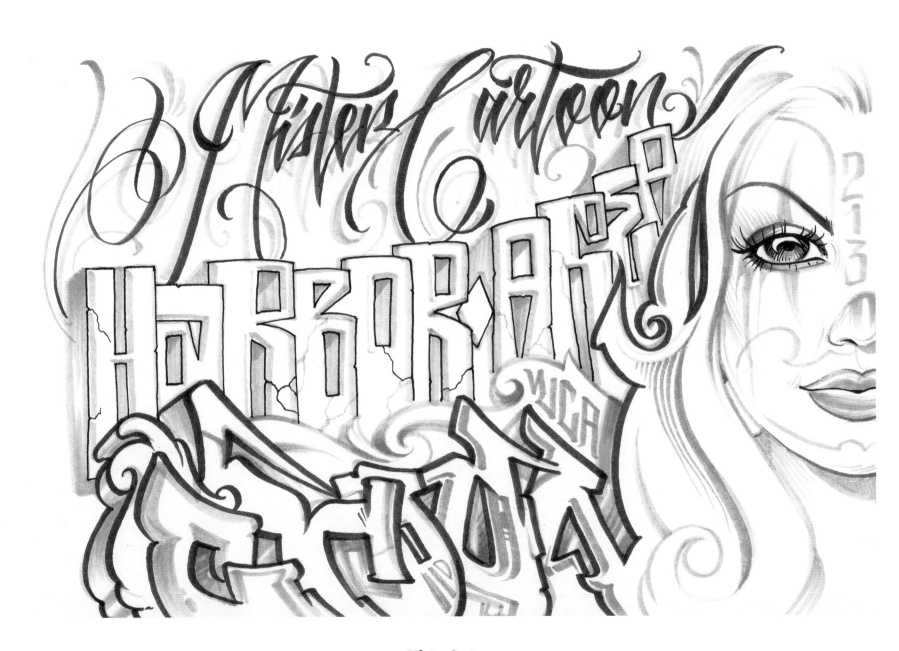

Mister Cartoon

NicNak

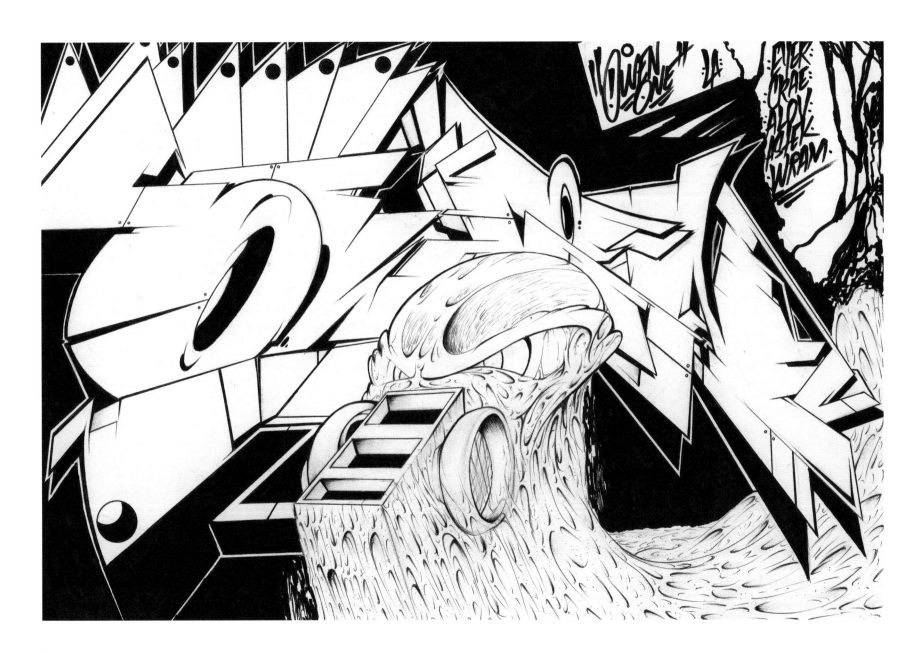

Owen One

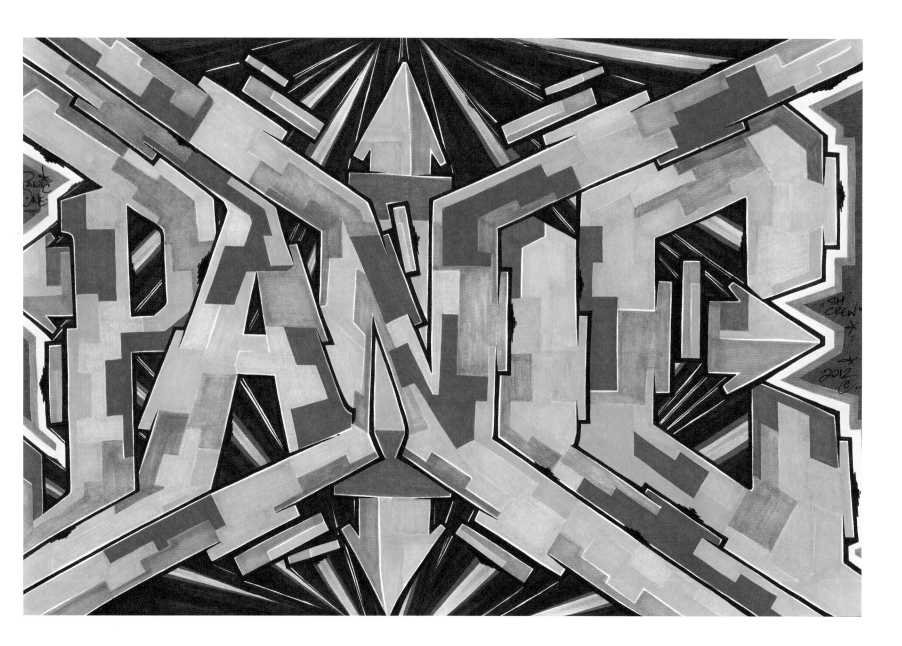

Panic One

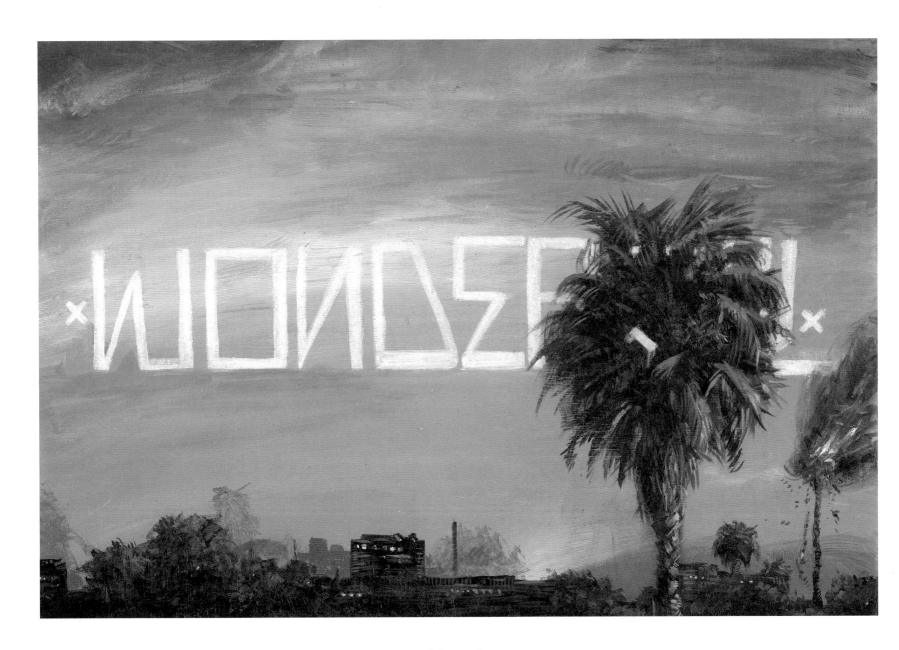

Patrick Martinez

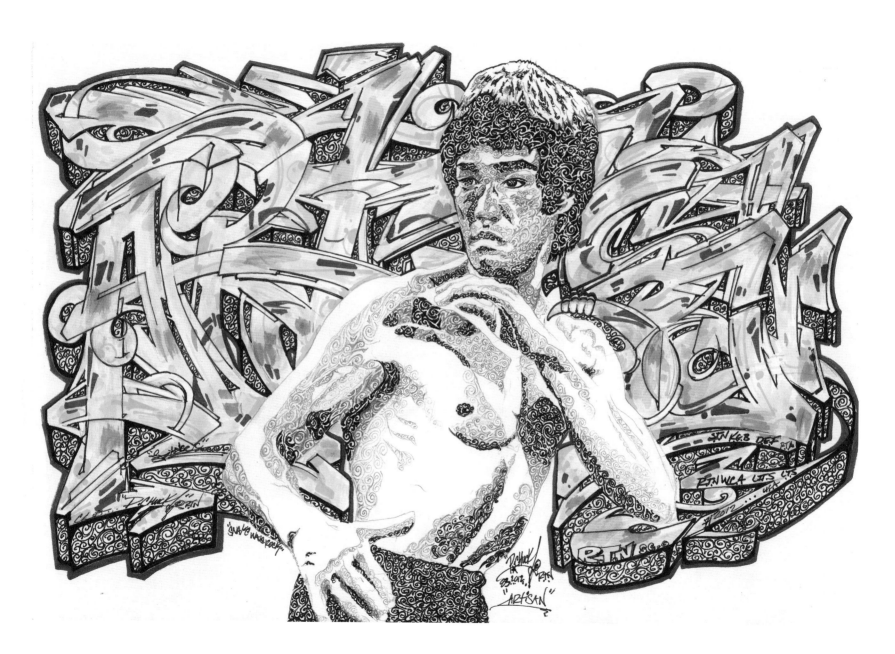

P.Chuck

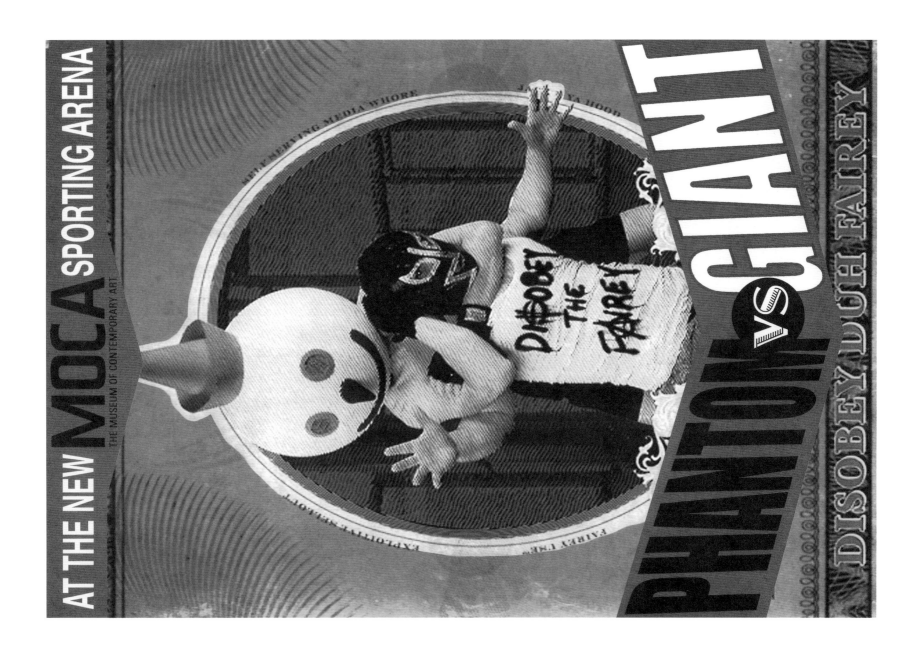

Phantom

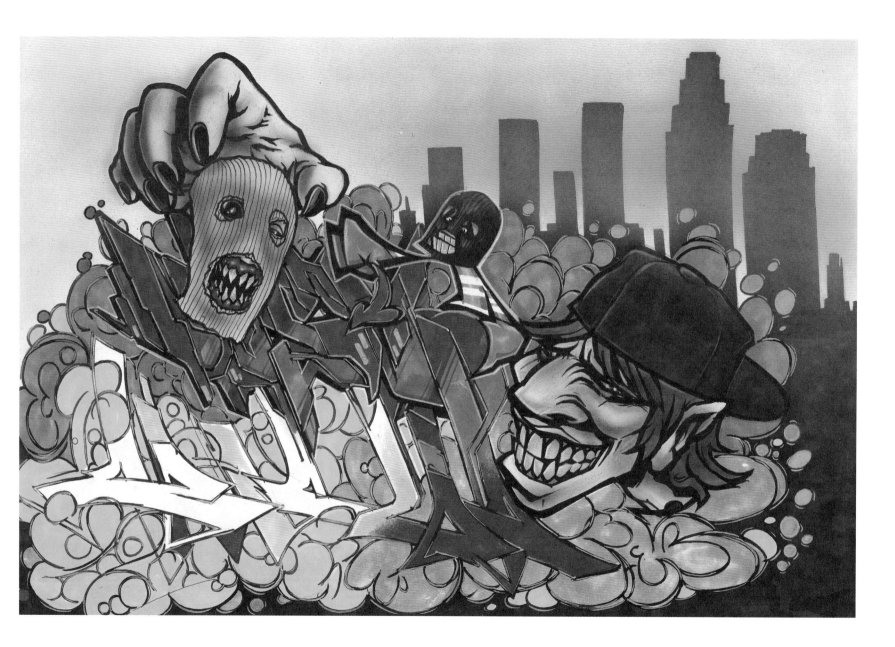

Phever

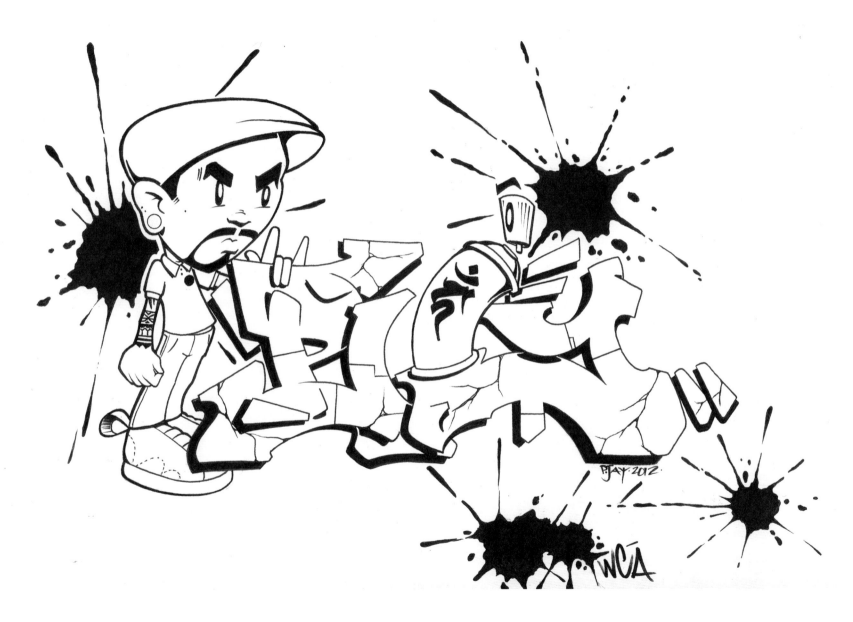

P. Jay One

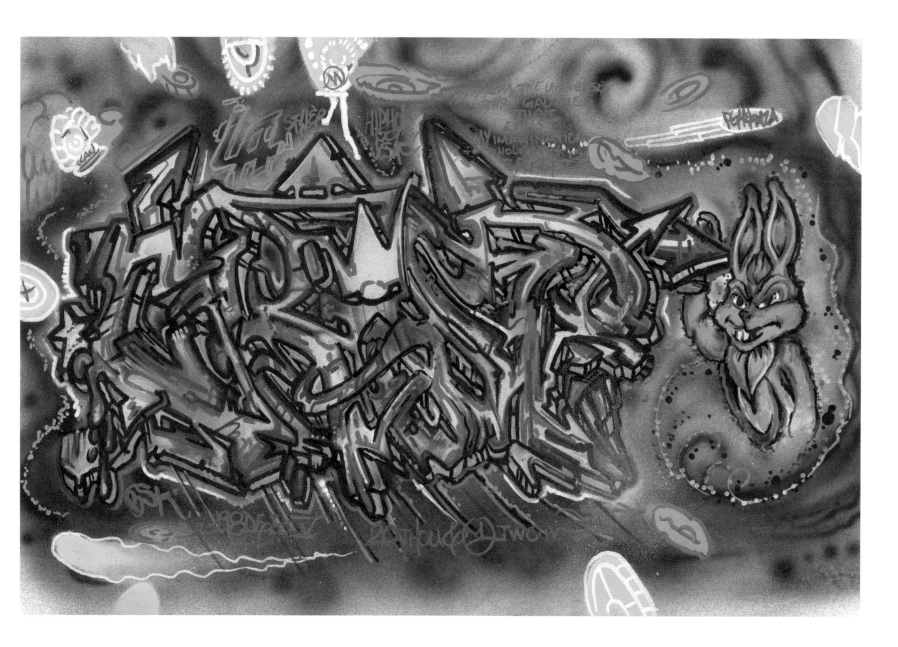

Playboy Eddie

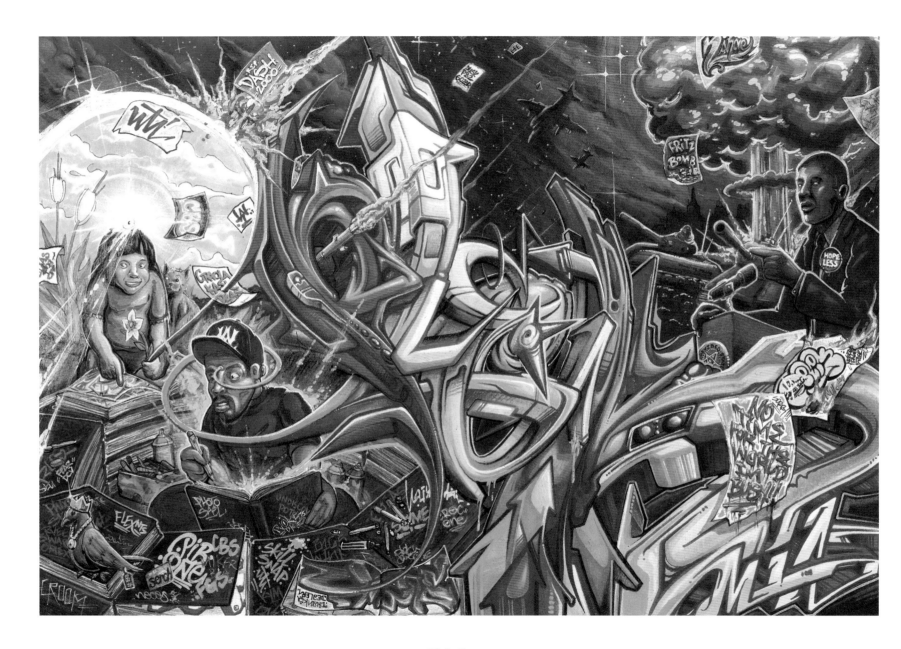

Plek One

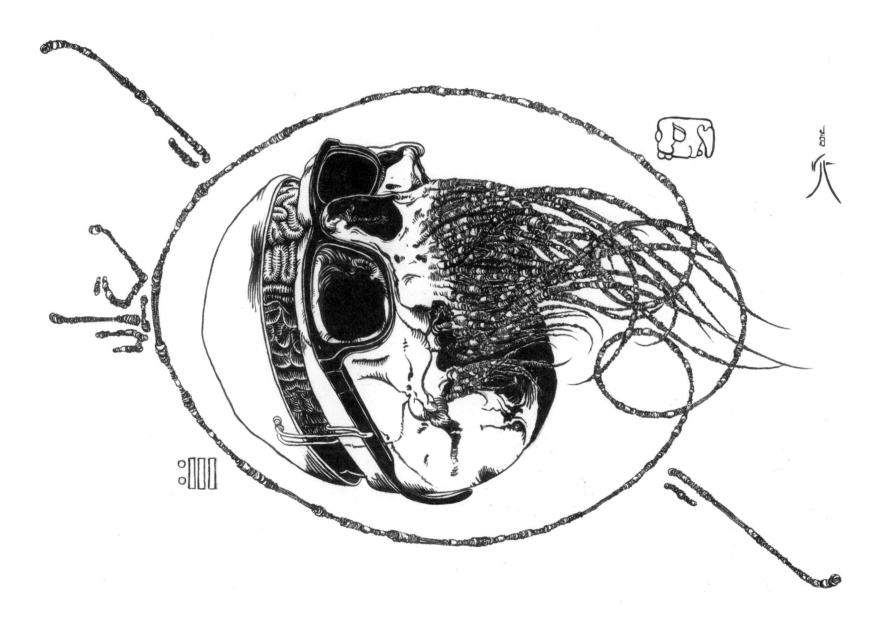

Pletk P17

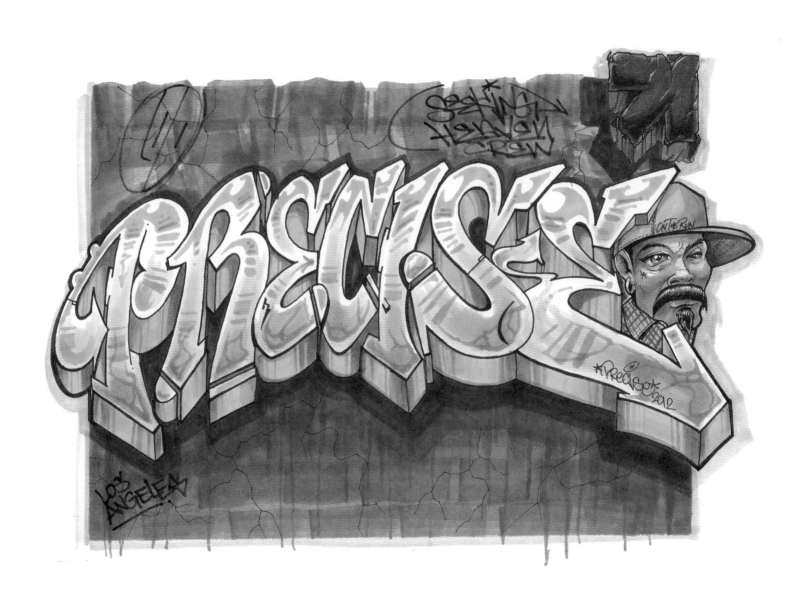

Precise

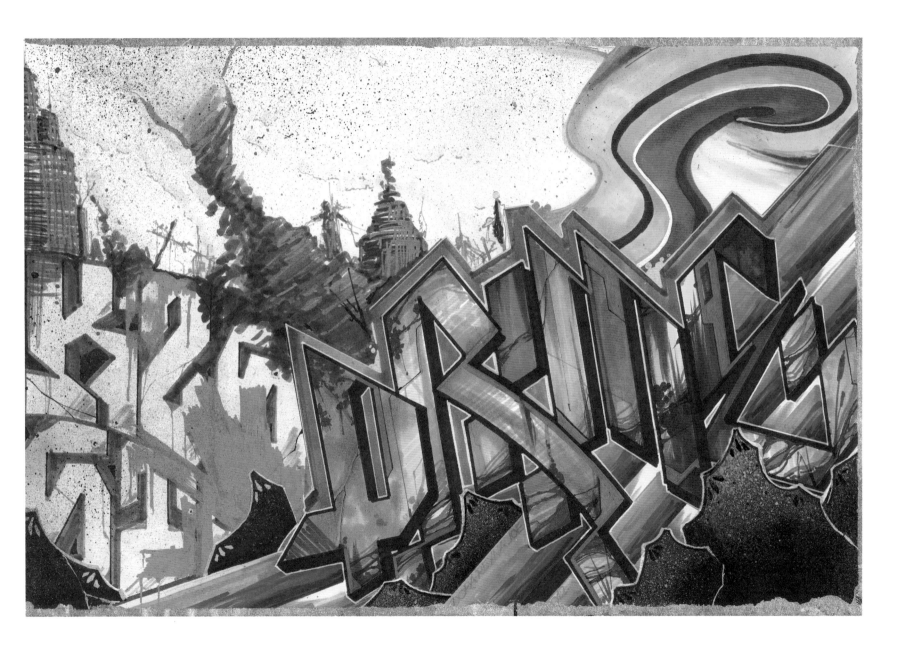

Prime

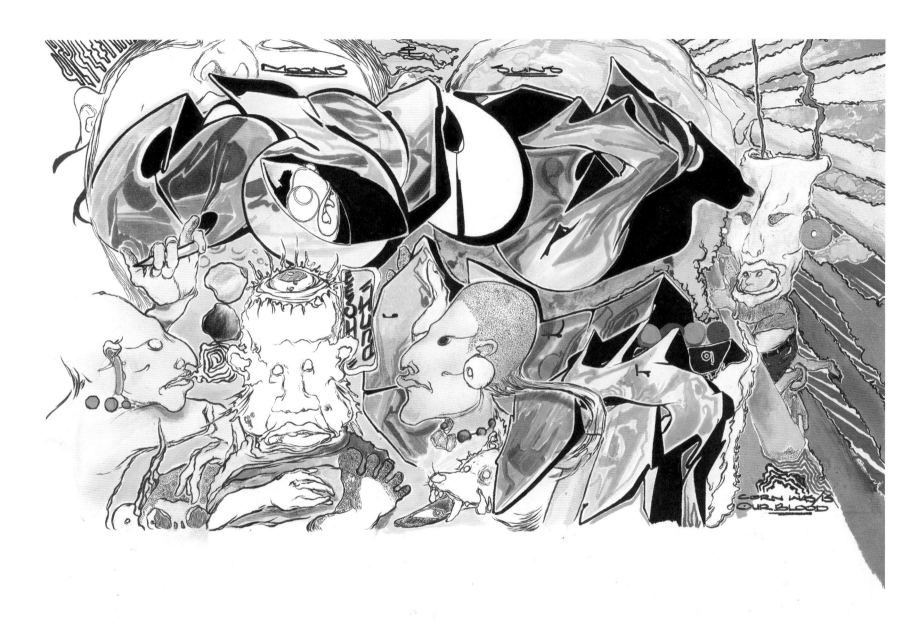

Punk

Push

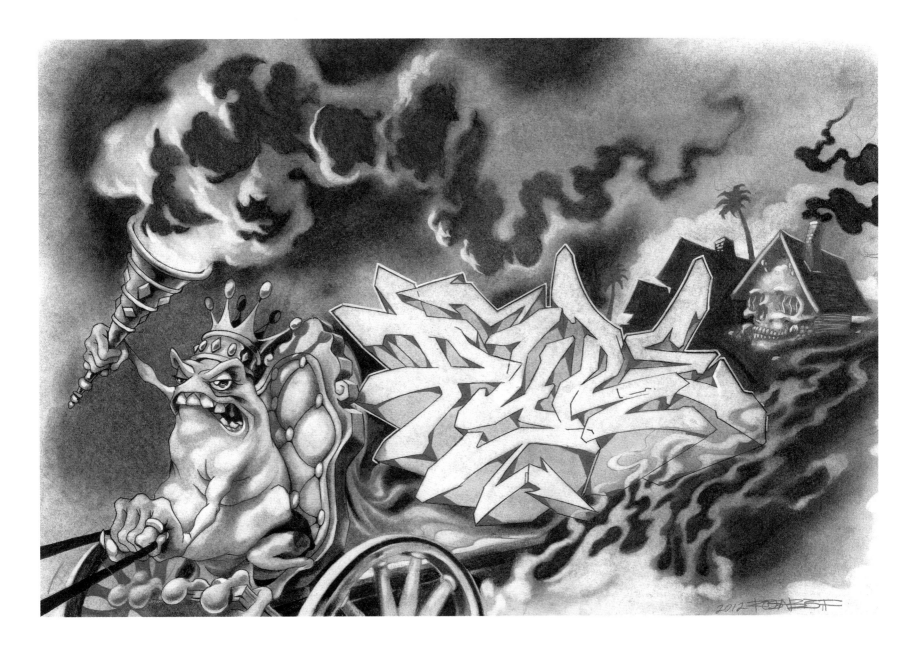

Pyre One

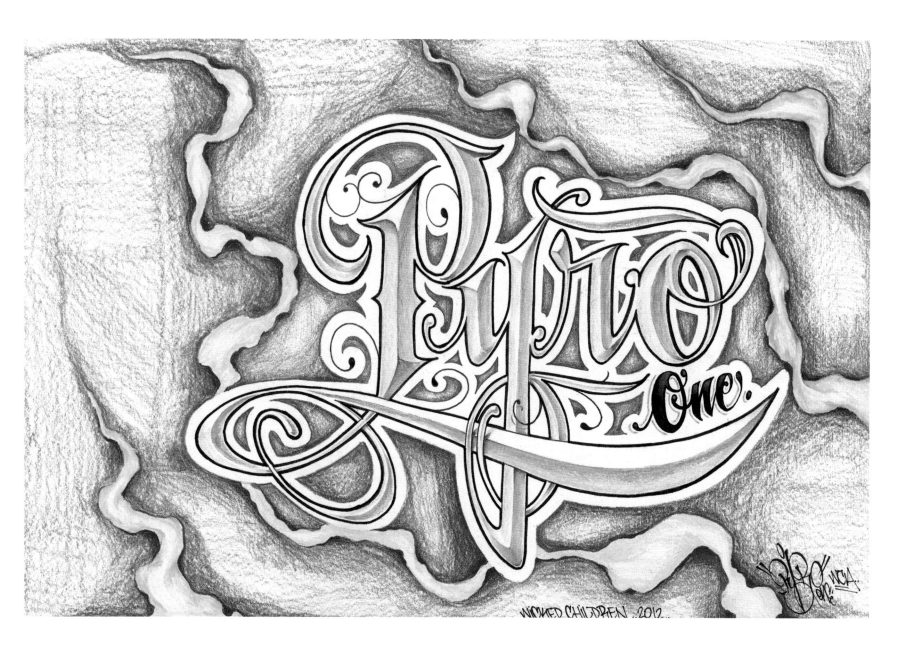

Pyro One

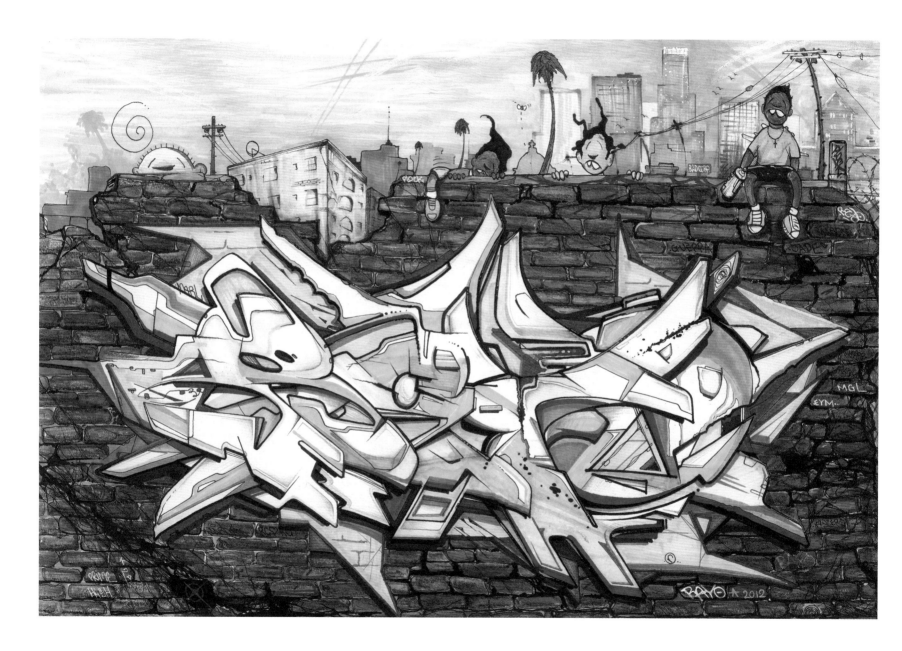

Rayo

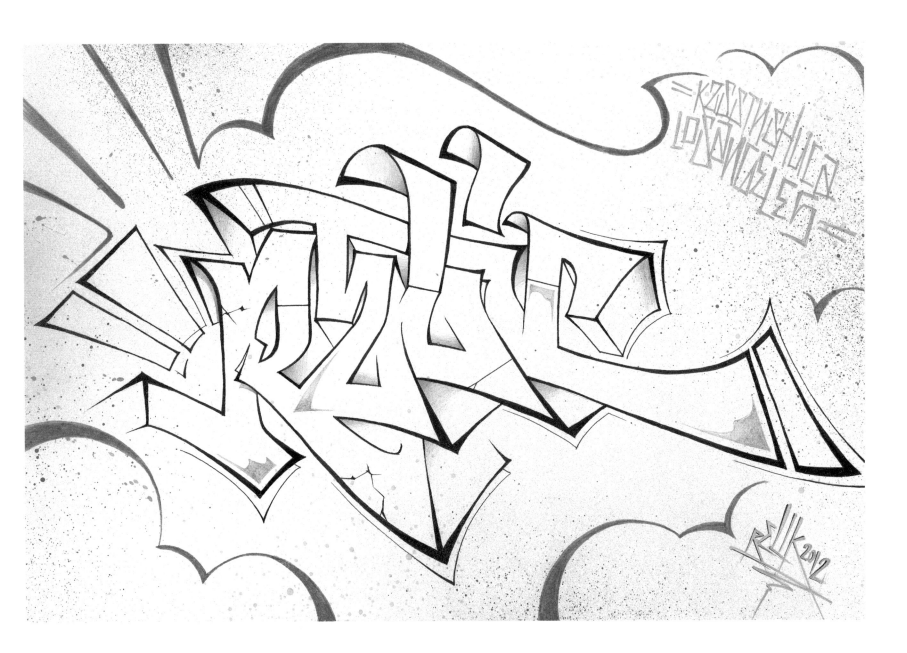

Relik

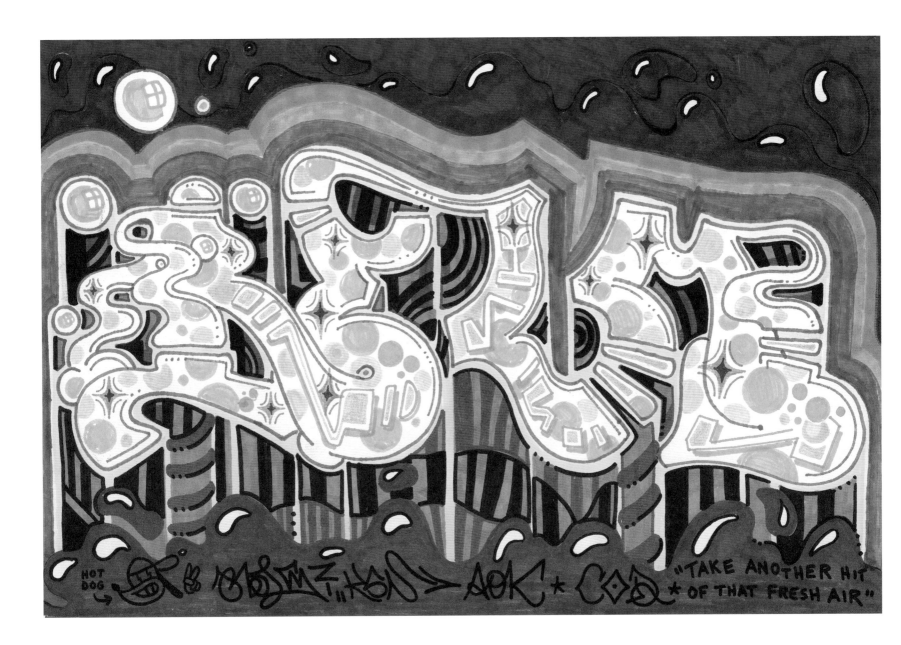

Relm

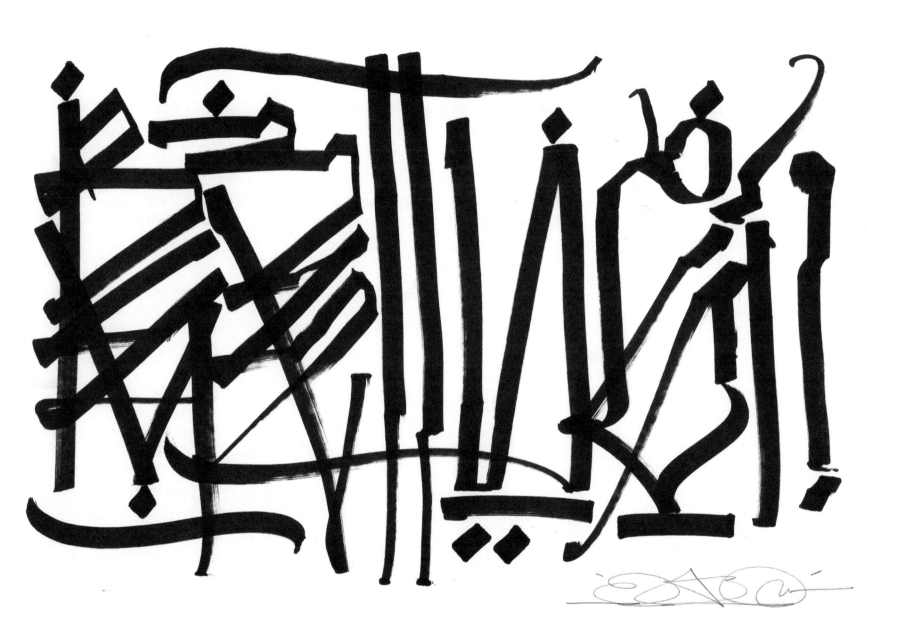

Retna

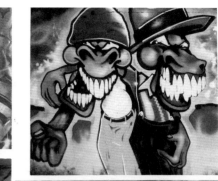
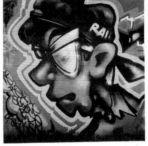

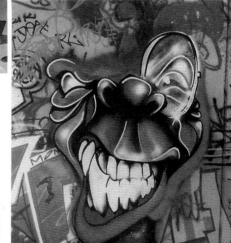
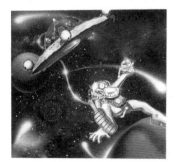

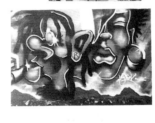

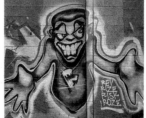
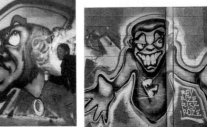

Rev

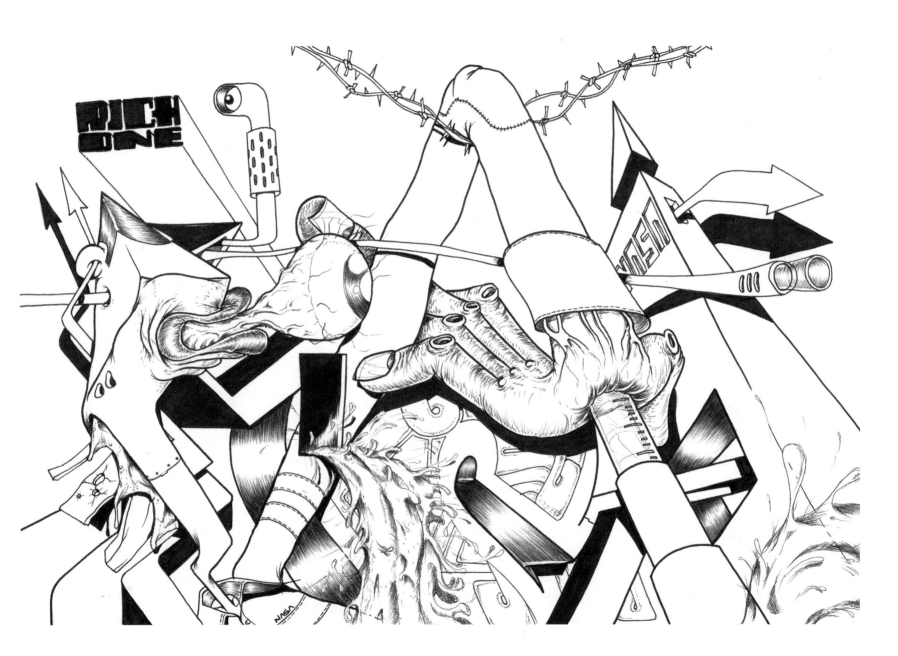

Rich One

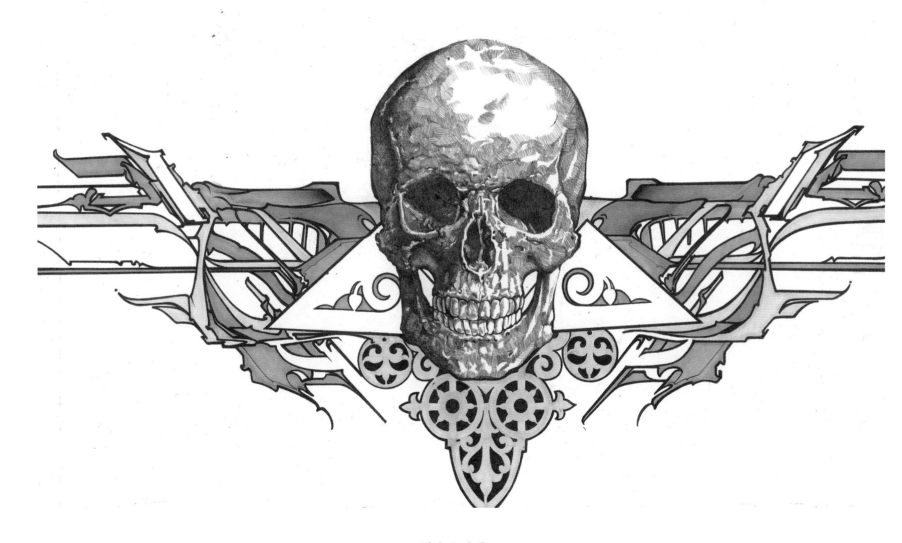

Rick Ordoñez

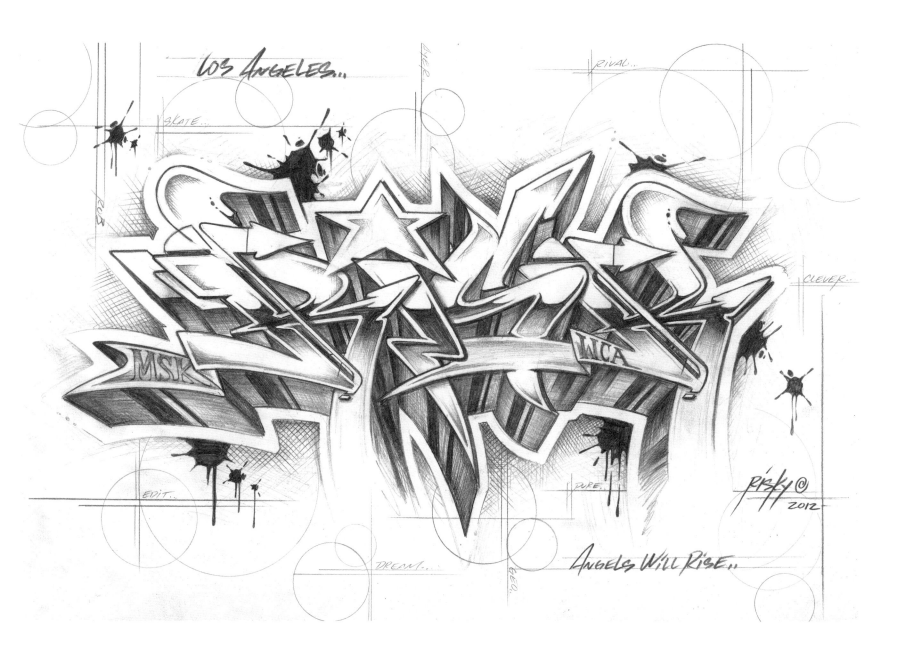

Risk

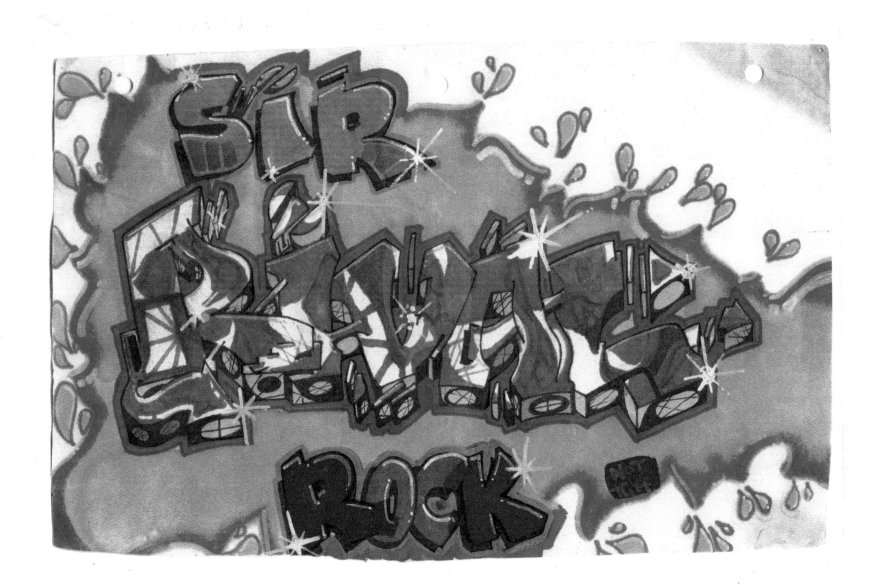

Rival

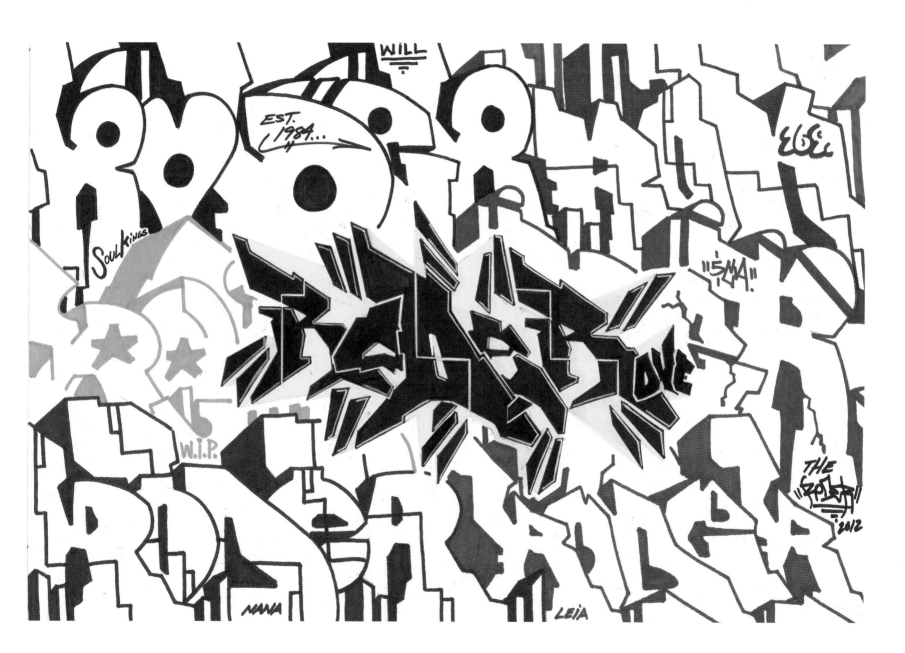

Roder 169

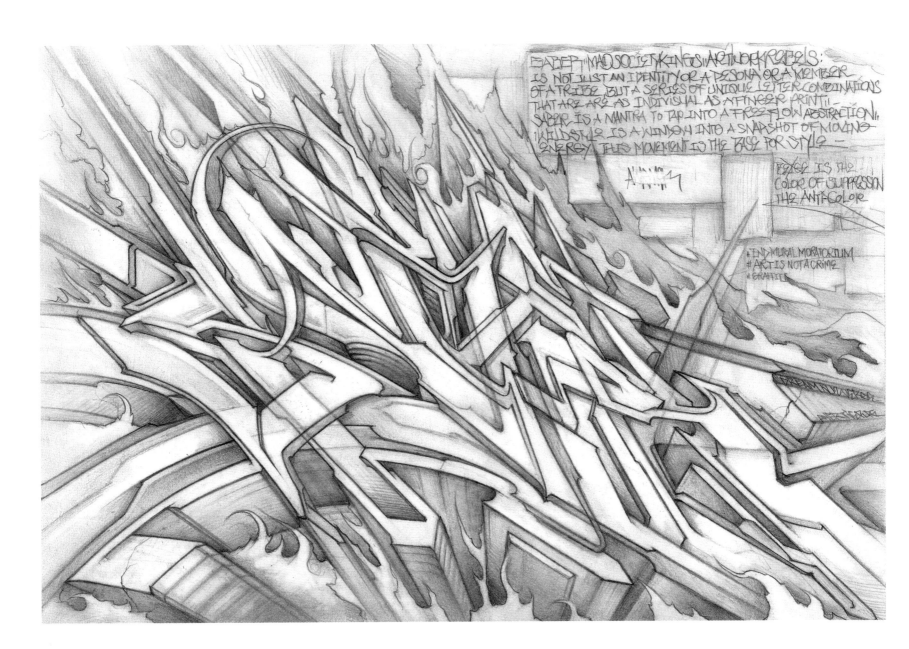

SABER "MAD SOCIETY KINGS" "ARTWORKREBELS"
IS NOT JUST AN IDENTITY OR A PESONA OR A MEMBER
OF A TRIBE BUT A SERIES OF UNIQUE LETTER COMBINATIONS
THAT ARE ARE AS INDIVIDUAL AS A FINGER PRINT !!
SABER IS A MANTRA TO TAP INTO A FREE FLOW ABSTRACTION!!
!! WILDSTYLE IS A WINDOW INTO A SNAPSHOT OF MOVING
ENERGY- THIS MOVEMENT IS THE BASE FOR STYLE —

BEIGE IS THE
COLOR OF SUPPRESSION
THE ANTI-COLOR

#END MURAL MORATORIUM
#ART IS NOT A CRIME
#GRAFFITI

Saber

Sacred 194

Sel

Ser

Shandu One

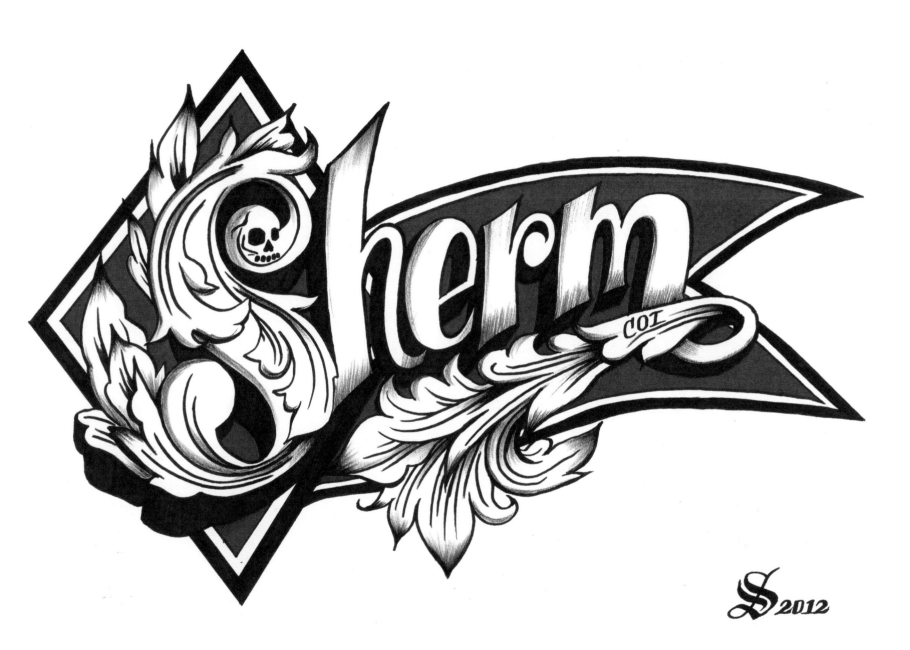

Sherm

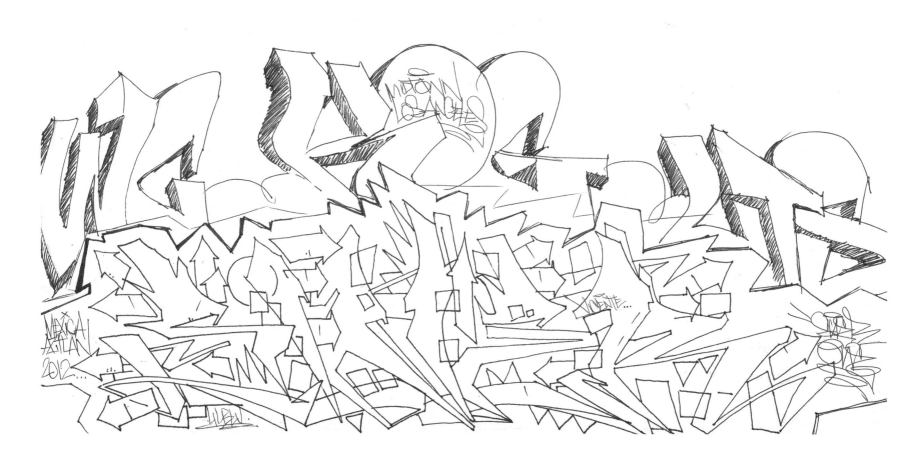

Siner

Skan One

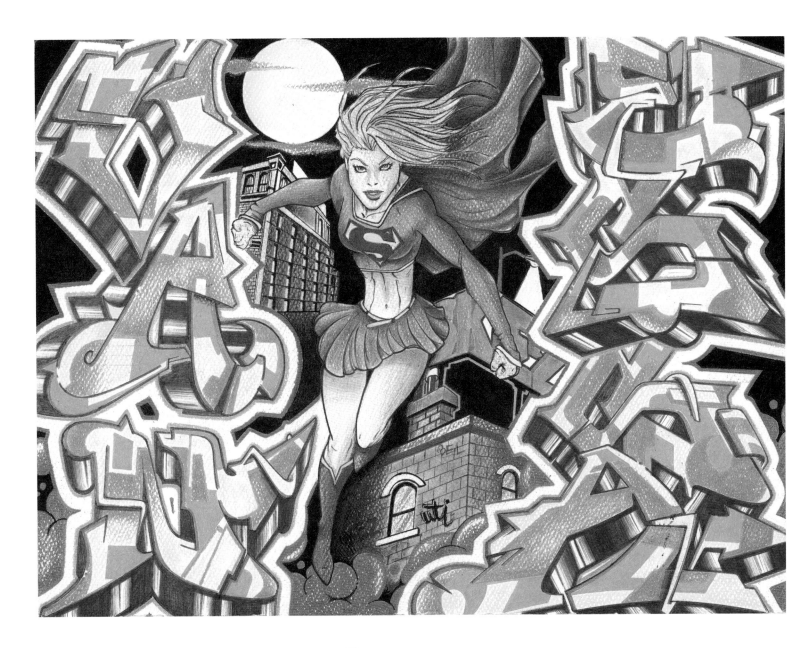

Skez

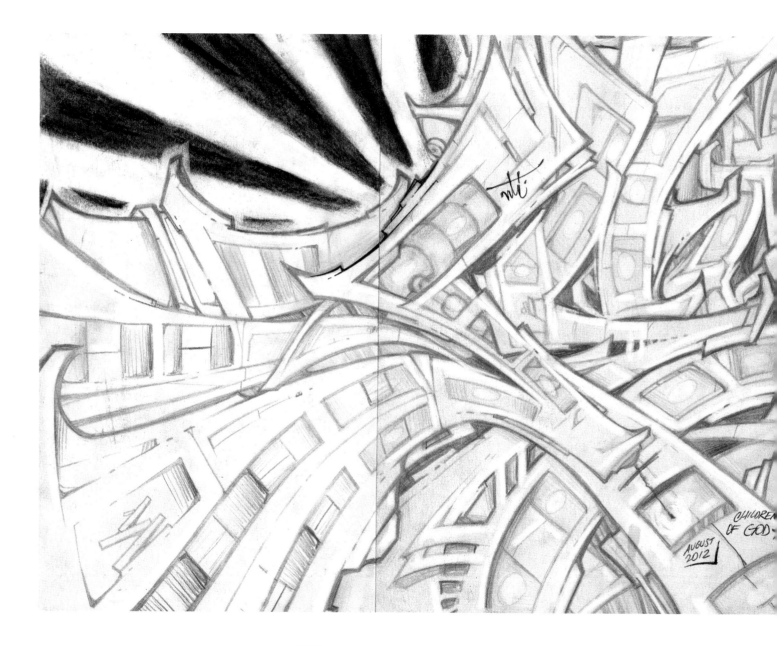

Skill

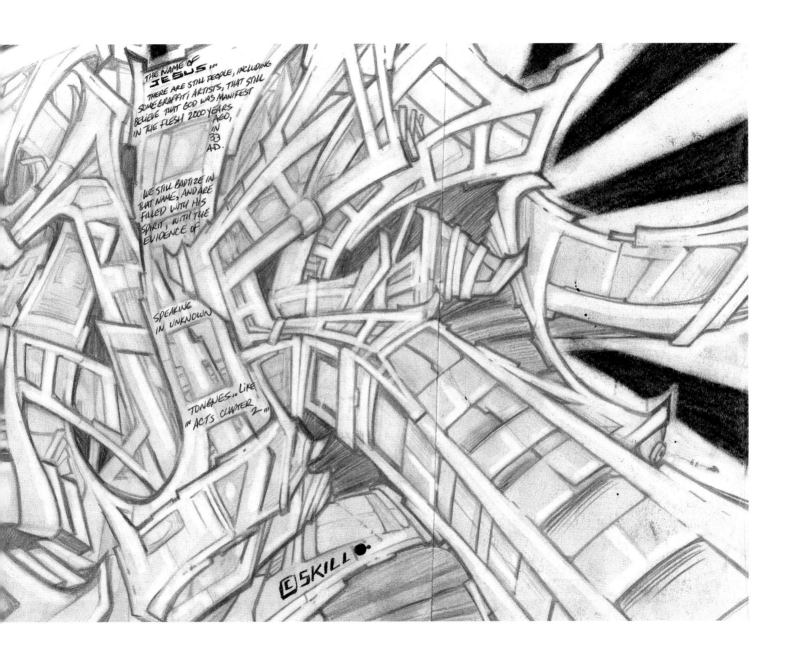

THE NAME OF
JESUS!"
THERE ARE STILL PEOPLE, INCLUDING
SOME GRAFFITI ARTISTS, THAT STILL
BELIEVE THAT GOD WAS MANIFEST
IN THE FLESH 2000 YEARS
AGO,
IN
33
A.D.

WE STILL BAPTIZE IN
THAT NAME, AND ARE
FILLED WITH HIS
SPIRIT, WITH THE
EVIDENCE OF

SPEAKING
IN UNKNOWN

TONGUES" LIKE
IN ACTS CHAPTER
2"

SKILL

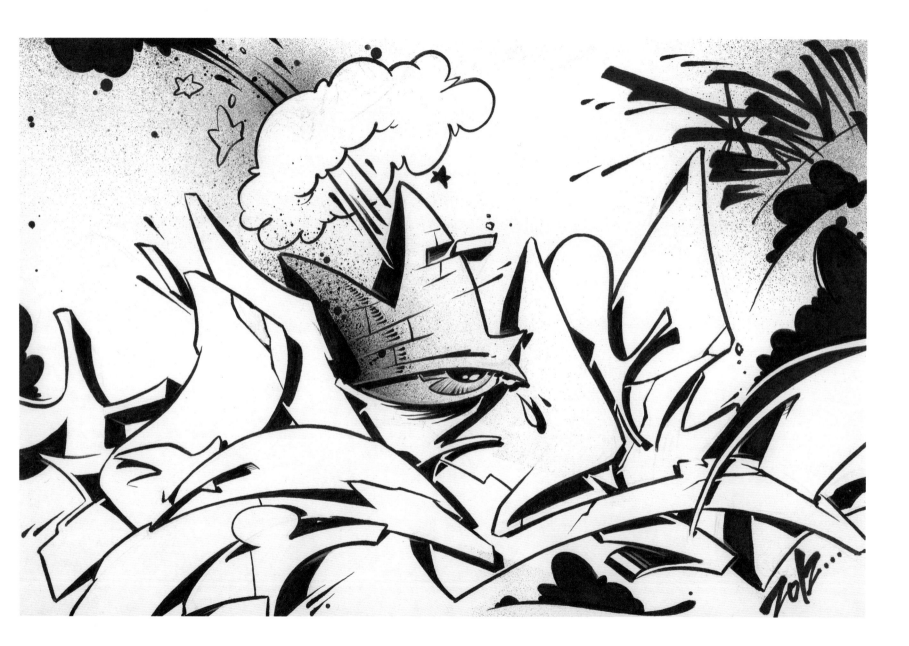

Slick

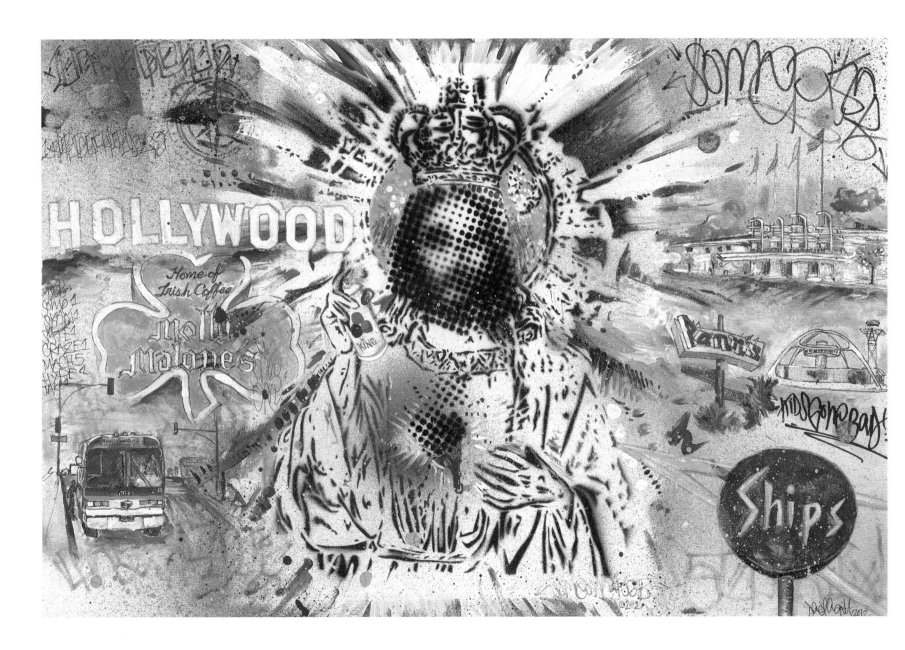

SomeOne

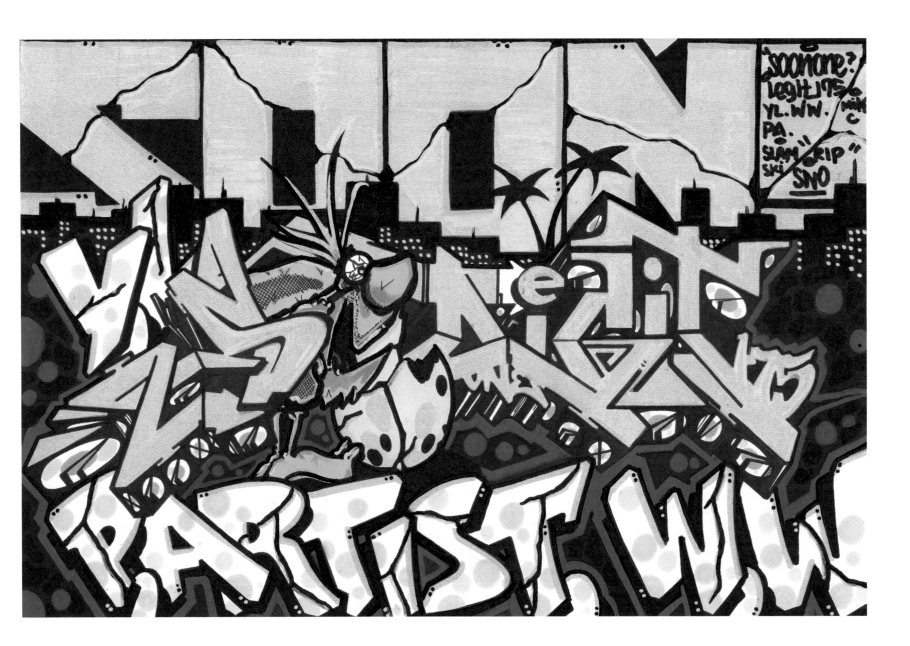

Soon One

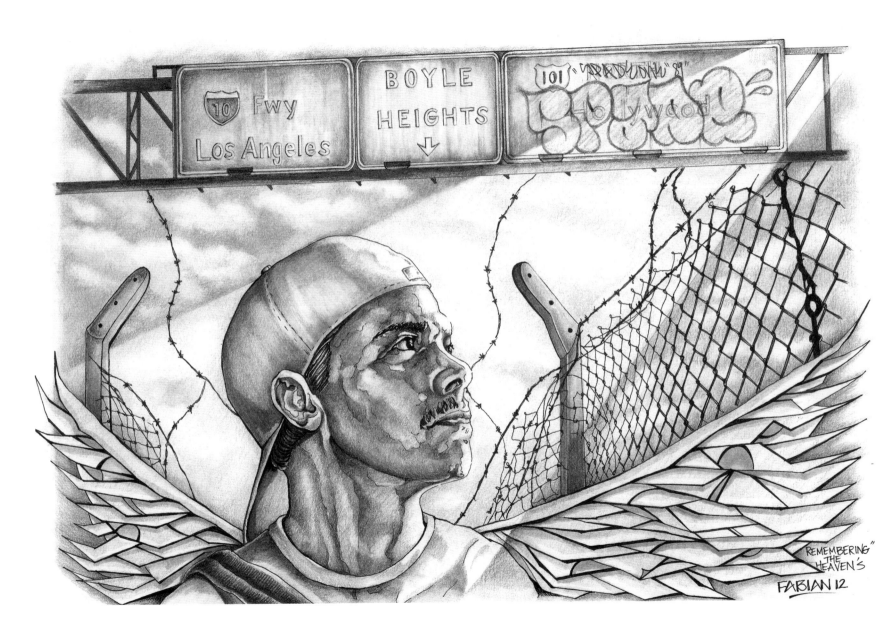

Spade

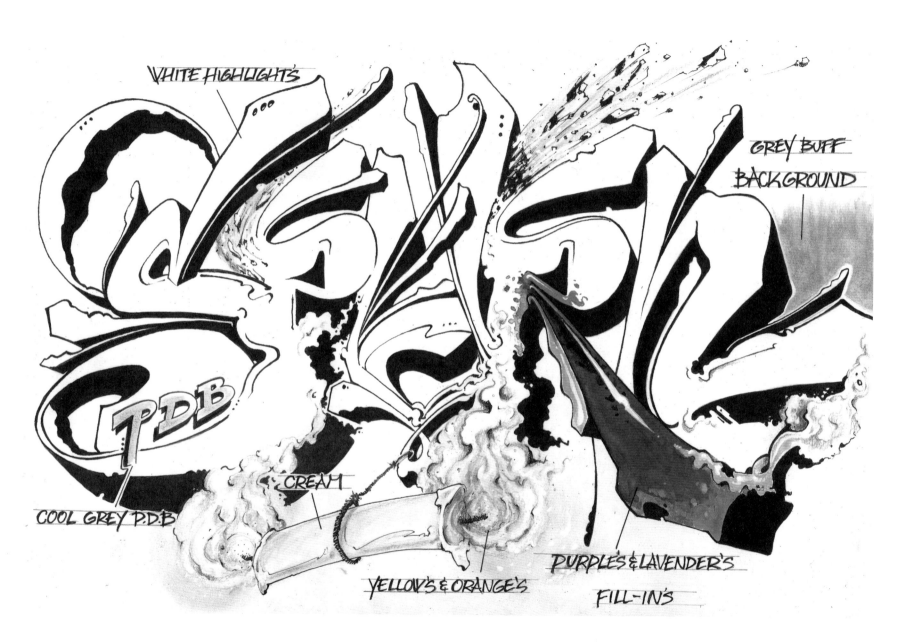

WHITE HIGHLIGHTS

GREY BUFF
BACKGROUND

PDB

CREAM

COOL GREY P.D.B

YELLOW'S & ORANGE'S

PURPLE'S & LAVENDER'S

FILL-IN'S

Spurn

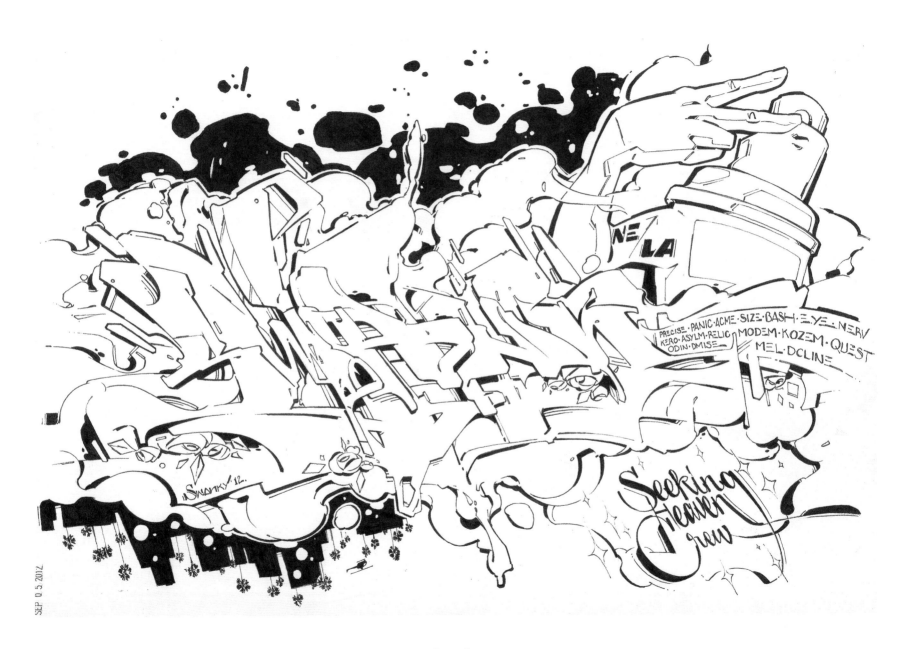

Swank

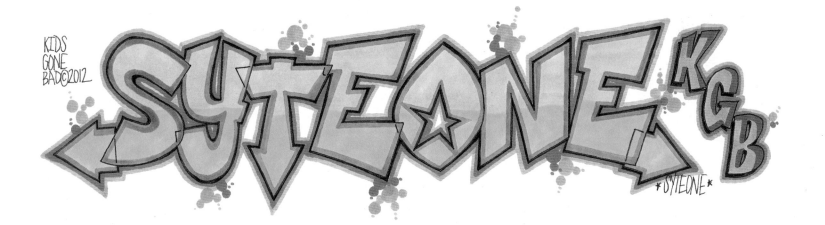

Syte One

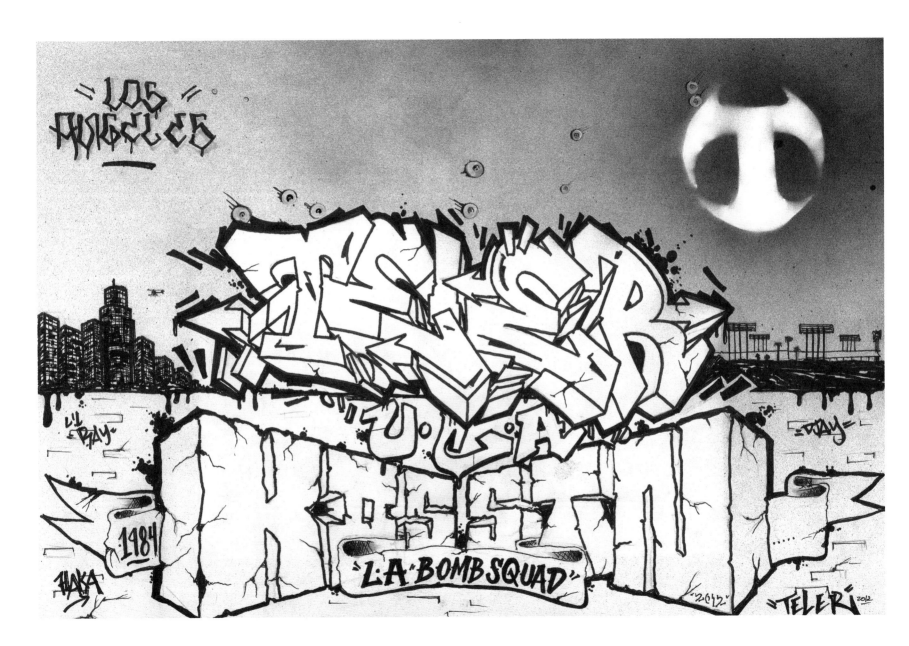

Teler

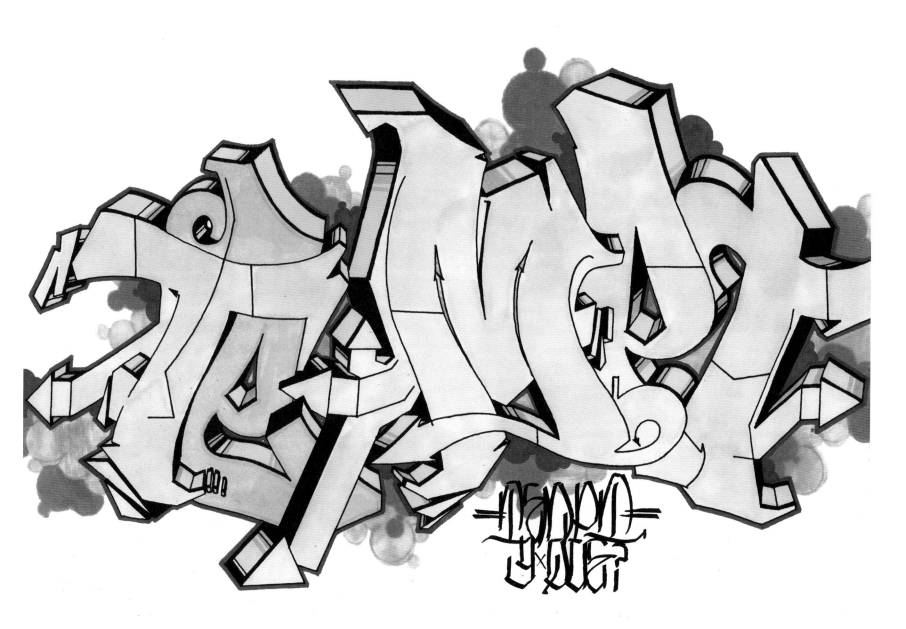

Tempt

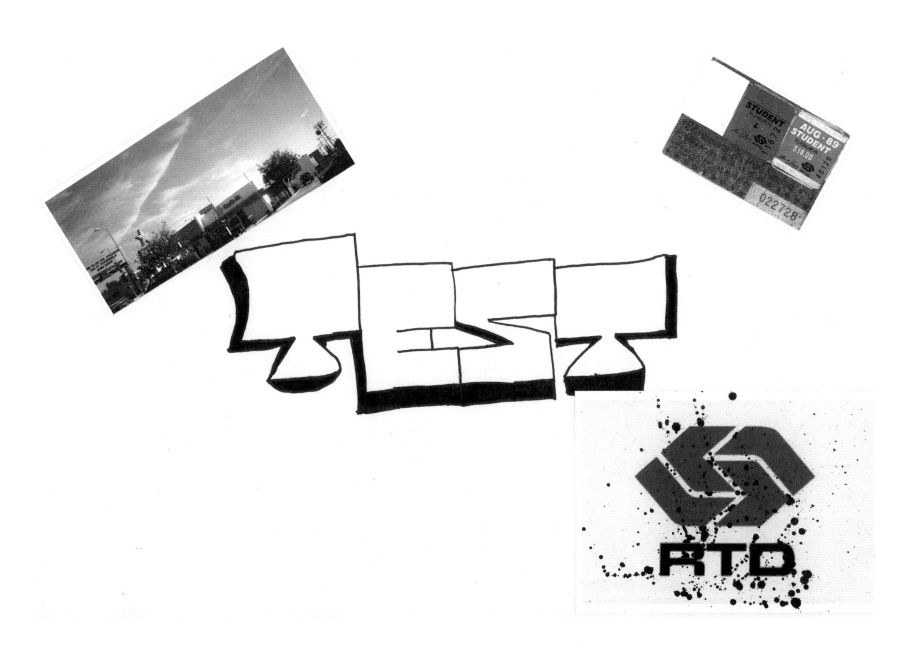

Test

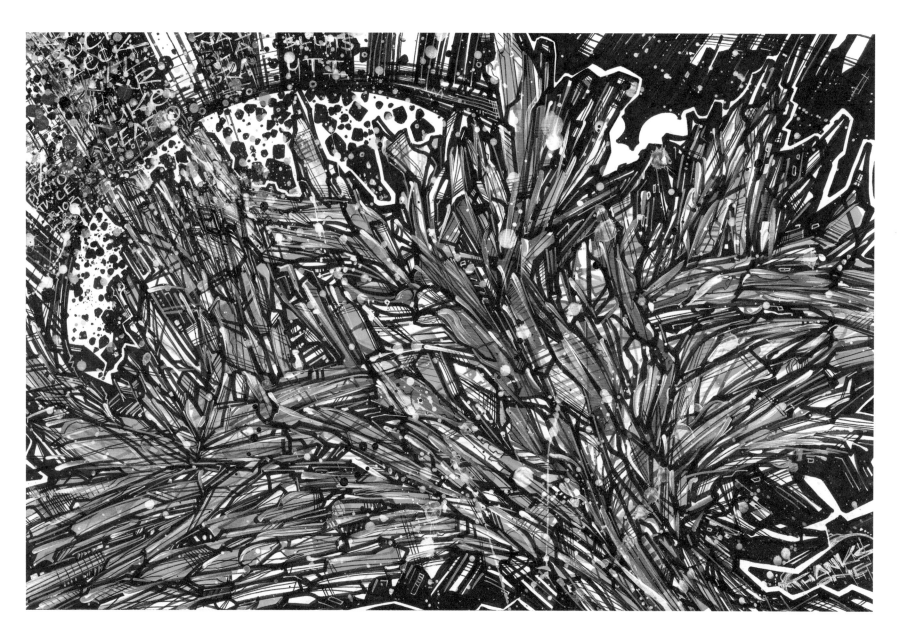

Thanks One

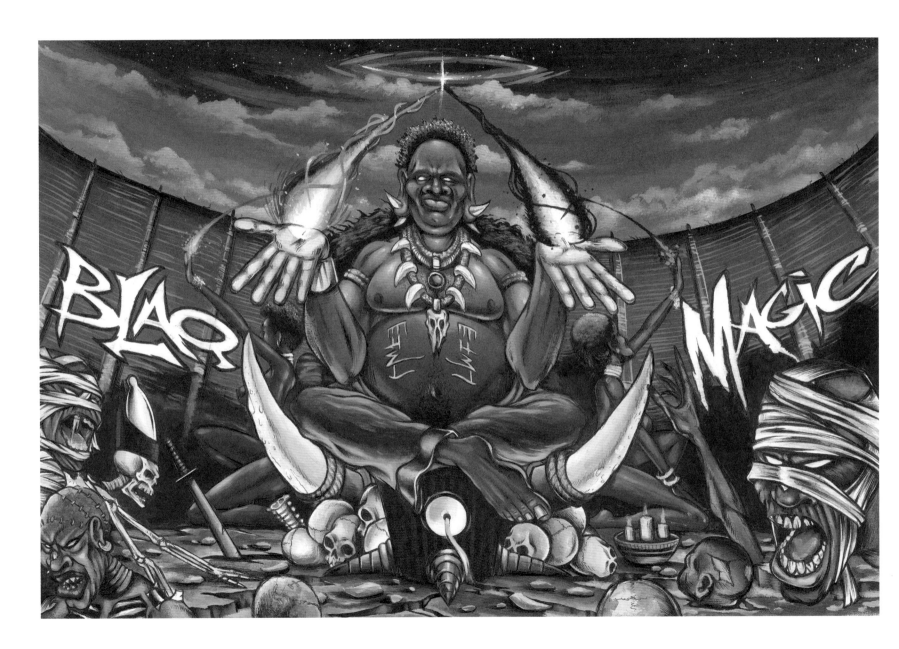

Thel

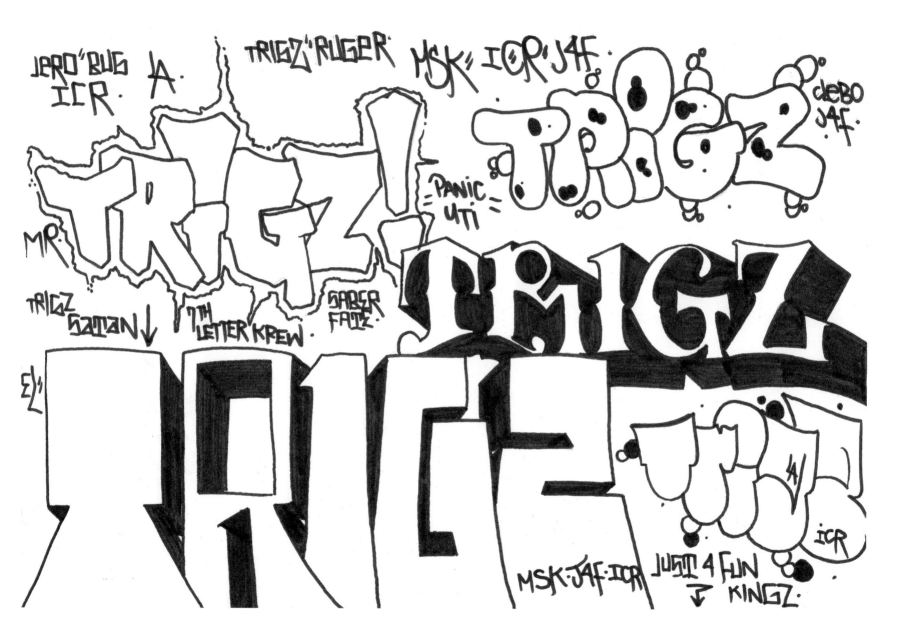

Trigz (front)

Trigz (back)

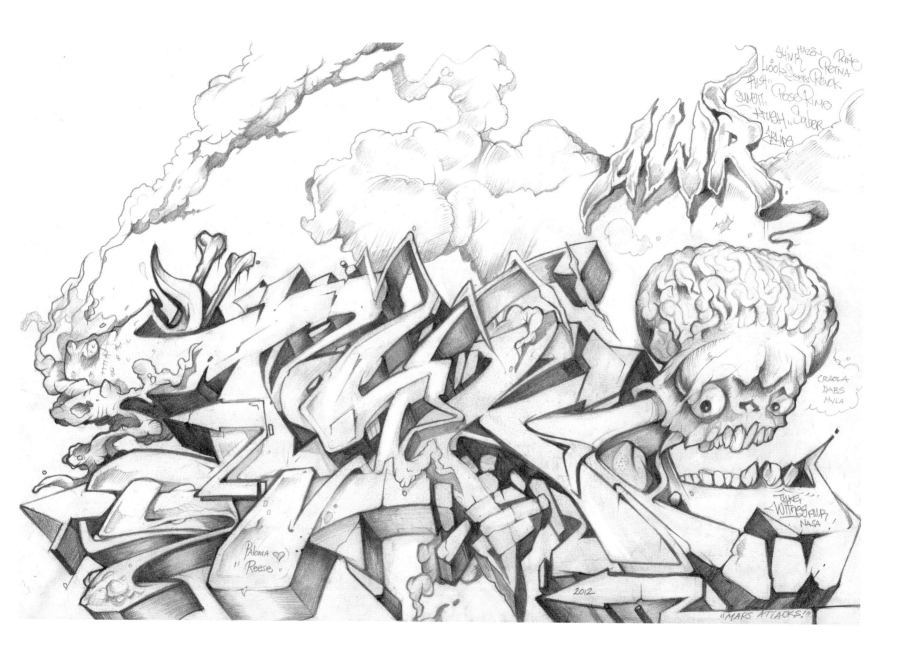

Tyke Witnes

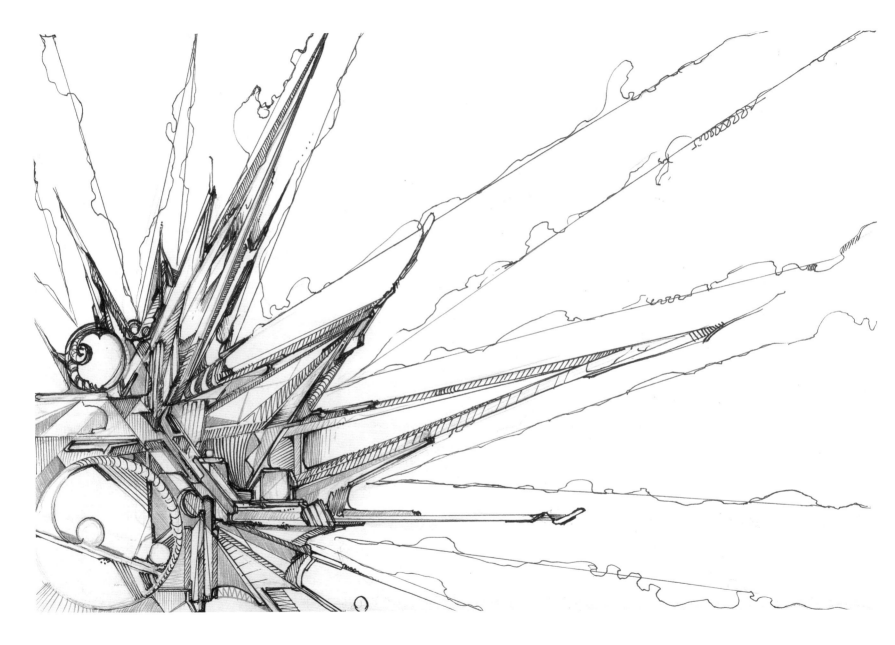

Useck

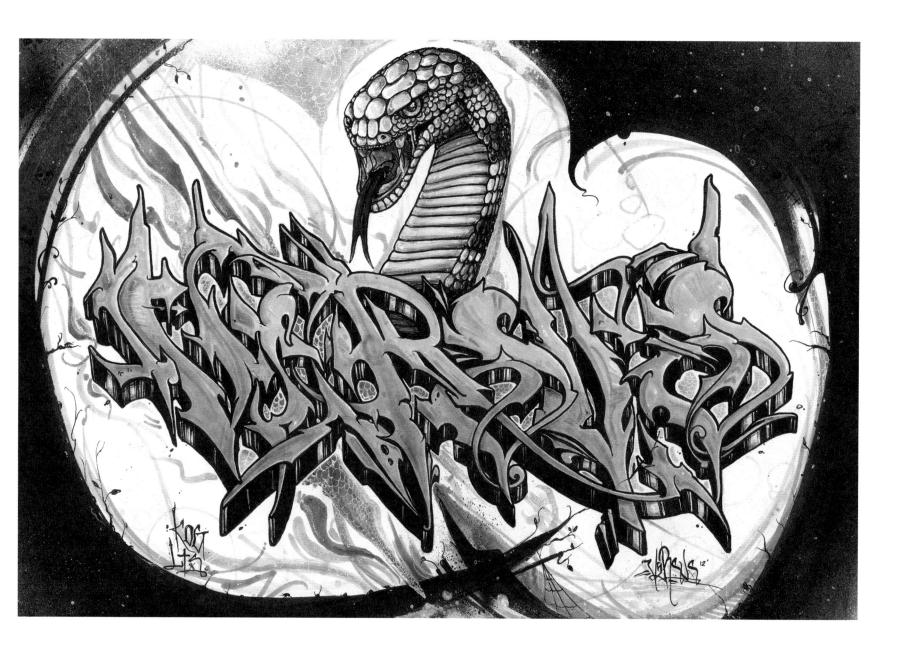

Versus 269

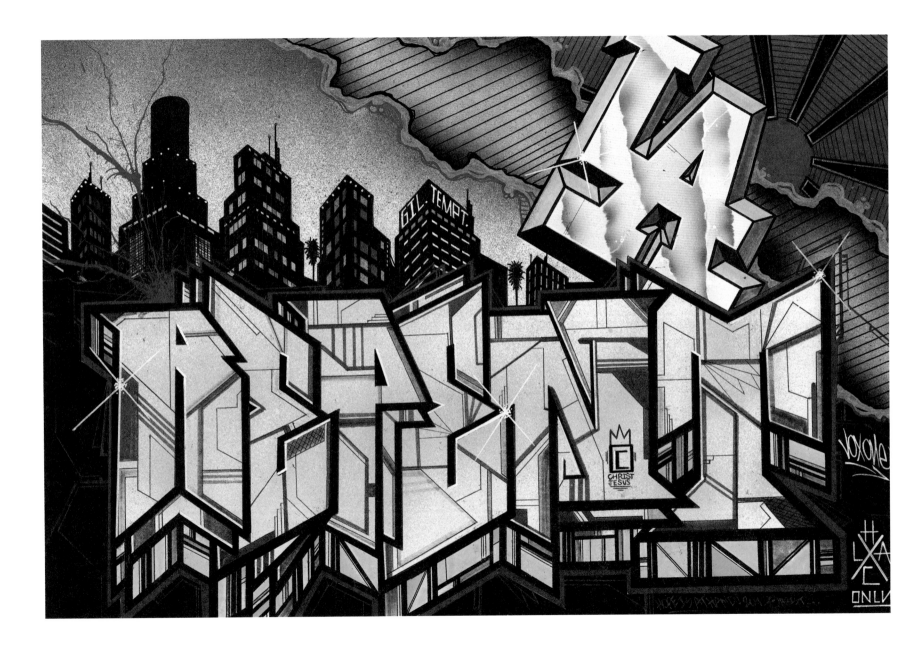

Vox One

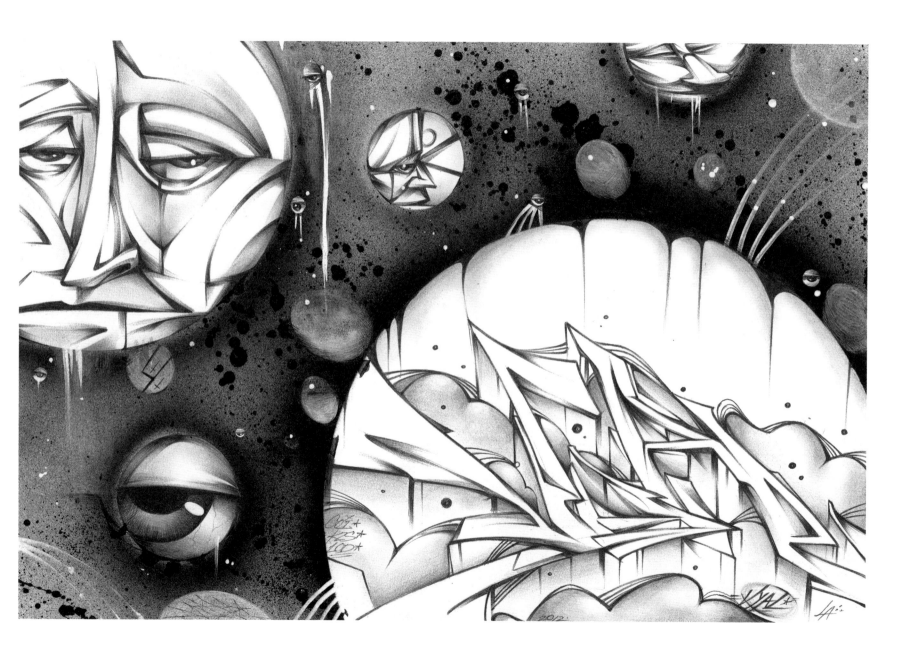

Vyal

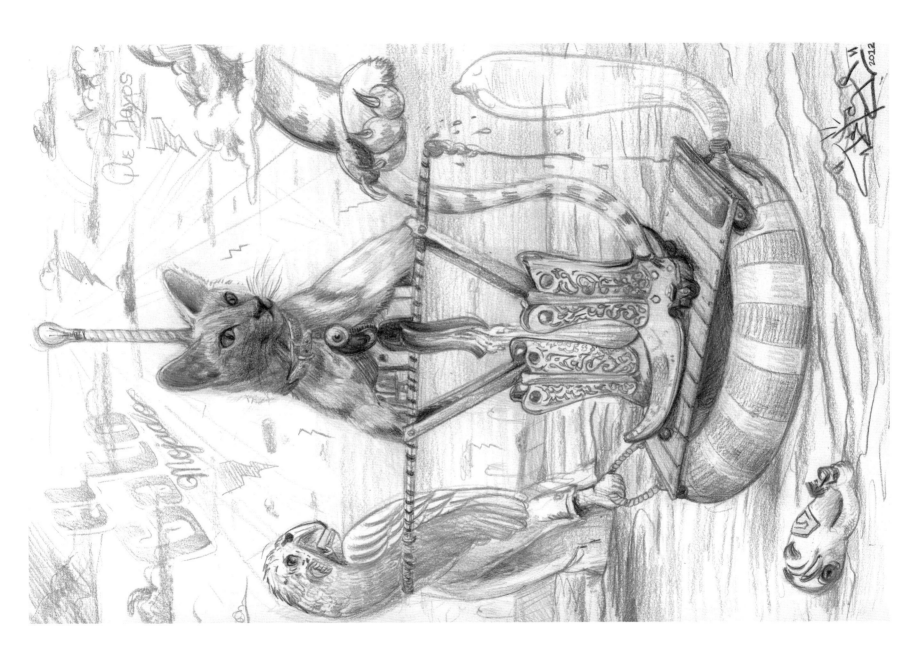

Werc

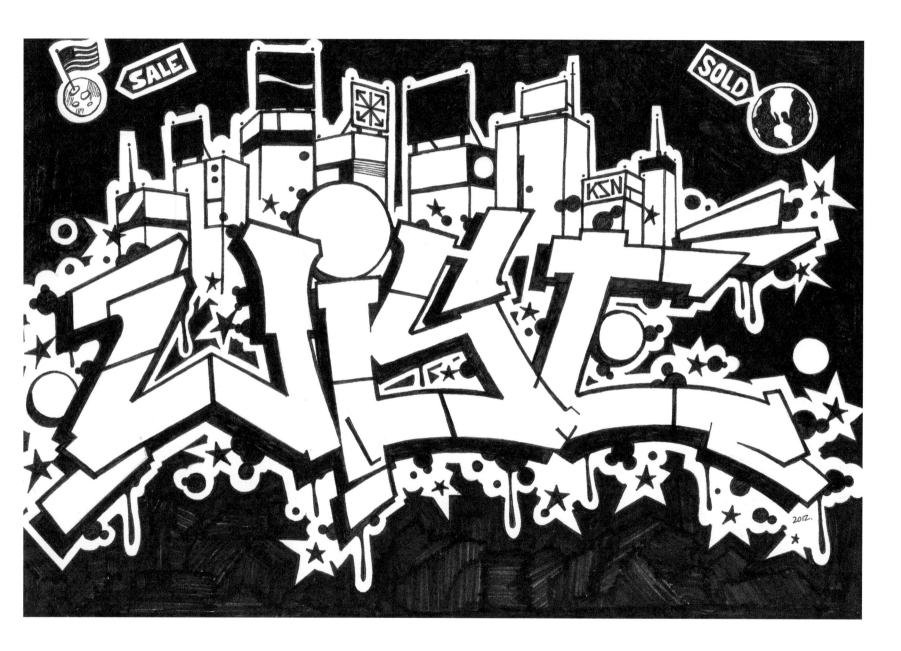

Wise

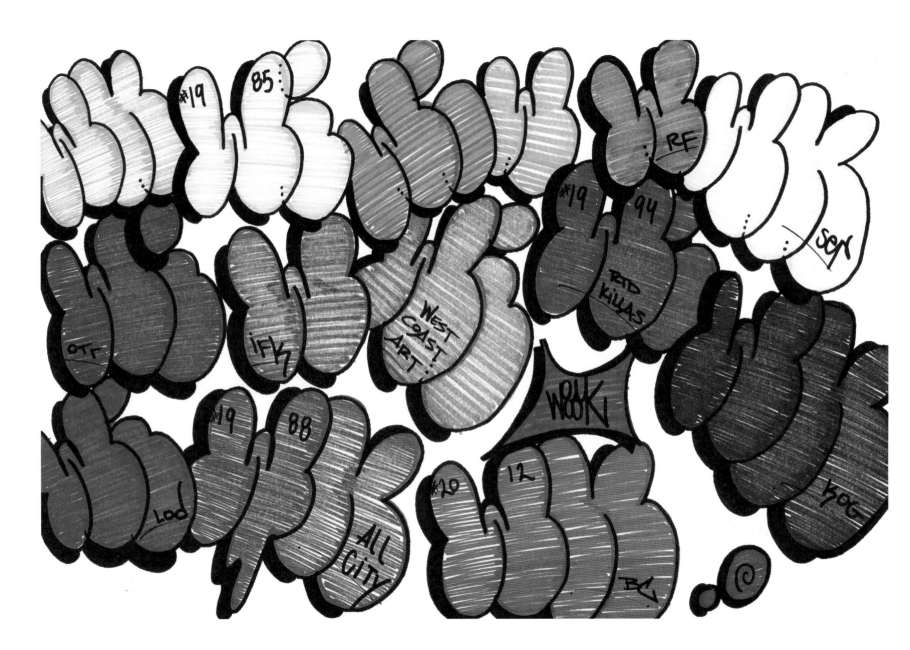

Wisk

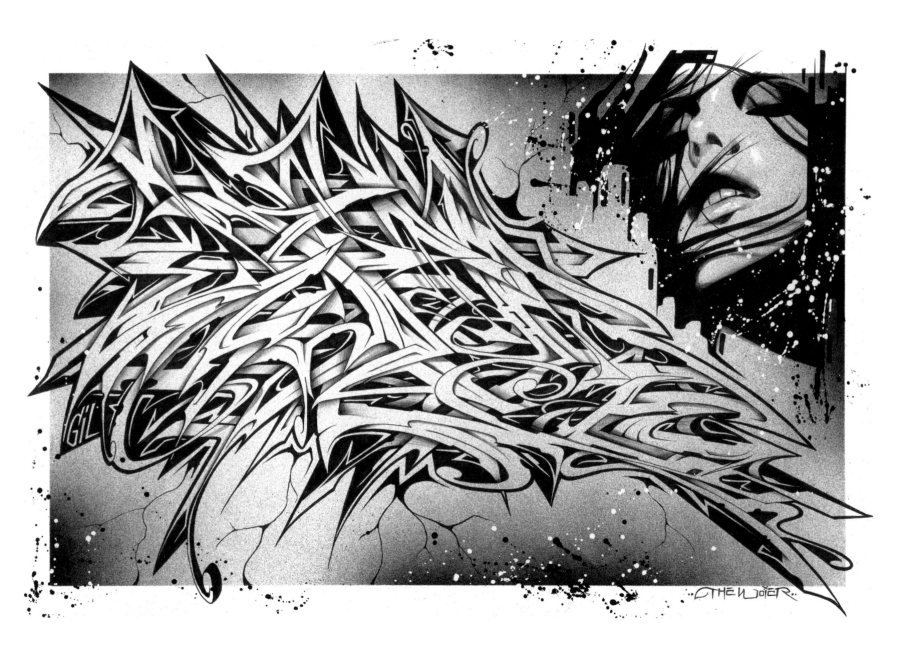

Woier

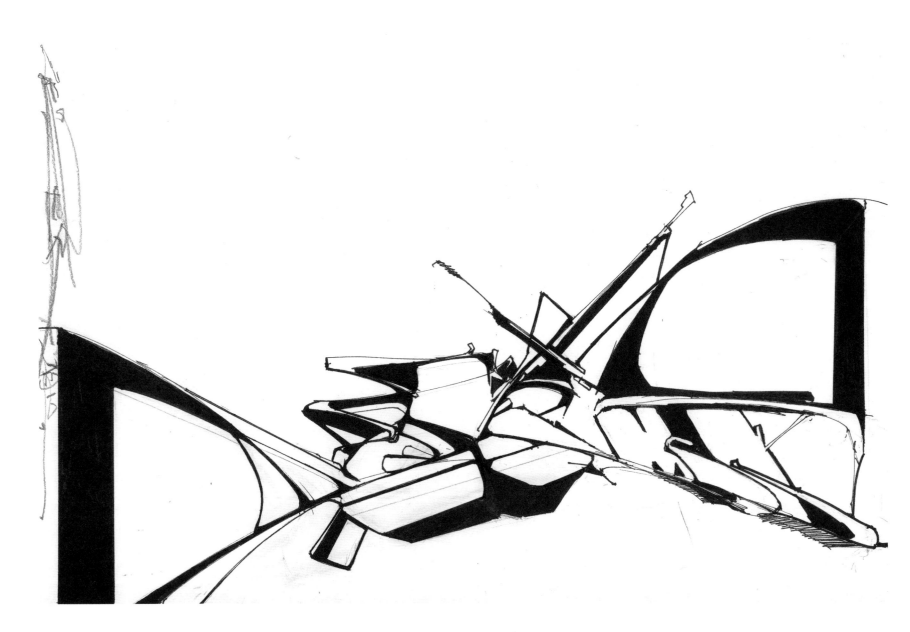

Zes

ACKNOWLEDGMENTS

What must be acknowledged at the outset is the gross mischaracterization of my contribution to this book as its "author." The creative output of some 150 artists, the spark of genius from an Angeleno collecting couple, and a rare books collection built by my predecessor are all more fundamental to the realization of this project. Finding myself in the midst of all this simply proves that I'm very lucky.

The *Getty Black Book,* also called *LA Liber Amicorum,* was the brainchild of Ed and Brandy Sweeney. Ed once told me that he was first inspired by graffiti art on a visit to the Los Angeles County Museum of Art, where he saw *Ride or Die,* a painting by Gajin "Hyde" Fujita that incorporated street-writing letterforms and figural elements. Brandy first learned about graffiti piece books as a student at Ripon High School. Years later, she expressed to her husband how cool, important, and apparently underrecognized these seemingly anonymous sketchbooks were in the art world. An artist now featured in this book, Juan Carlos "Heaven" Muñoz Hernandez, began connecting the Sweeneys to L.A. street writers and their painted urban world. From these initial explorations of L.A. graffiti art emerged the vision for a citywide "master-piece" book, which would eventually result in the *Getty Black Book.* It was an immense undertaking, especially for Ed, who devoted countless hours to talking to artists about the project and eliciting suggestions for more contributors. This art trek came at the expense of family time, and I wish to express my gratitude to Patrick and Cora Sweeney for the yearlong loan of their father. Thanks to the Sweeneys' generosity, the *Getty Black Book* is now housed in the vaults of the Getty Research Institute (GRI). This publication is dedicated to the Sweeneys as a sincere token of gratitude.

Once launched, the project seemed to grow organically, fueled by the goodwill of a creative community of L.A. artists that includes Chaz, Prime, Big Sleeps, Defer, Axis, Fishe, EyeOne, Risk, King Cre8, Heaven, Hyde, Patrick Martinez, Man One, Kofie, Jero, Siner, Look, and Saber, to name but a few. They transformed the embryonic notion of a Getty black book into a true L.A. book of friends, and they cannot be thanked enough for their efforts. Through them, the community grew to encompass more than 150 talented individuals from all over the city, each of whom generously donated a thoughtfully conceived and beautifully executed work of art for inclusion in this unique collection. This volume is also dedicated equally to each and every artist who participated in its creation. Too numerous to list here, but showcased throughout this book, they compose and are the composers of *LA Liber Amicorum.*

I am grateful to Marcia Reed, chief curator at the GRI and formerly its rare books curator, for bringing the Sweeneys and the *Getty Black Book* into my life. When the Sweeneys broached the project to Marcia, it was she who introduced them to me and encouraged me to embark upon this ingenious collaboration.

Lisa Cambier, then my administrative assistant, was tireless in her commitment, brilliant in her ability to seamlessly navigate an endless stream of logistical demands, and completely genuine in the warmth with which she treated all involved. She wrangled every detail on the institutional side as ideas and paper became the *Getty Black Book,* and she then helped that book become an exhibition. I doubt I could have accomplished either without her.

My profound thanks go to everyone at ESMoA who made the *SCRATCH* exhibition possible, foremost to Eva and Brian Sweeney, the founders of that nonprofit experimental art laboratory, and to Bernhard Zünkeler, its creative director. I must also give high praise to the curators of the art walls there—Miner, Axis, King Cre8, EyeOne,

Defer, and Fishe—and bestow honorable mentions on surprise contributions from Saber, Vyal, Plek One, Fearo, AiseBorn, Prime, Big Sleeps, Heaven, and Phantom.

I wish to thank Steve Grody, the dean of L.A. graffiti history, for his time and expertise.

I am grateful to GRI director Mary Miller and associate director Gail Feigenbaum, and to Getty Publications publisher Kara Kirk, for their support of the present volume. The team at Getty Publications has brought notable enthusiasm to the project, and it is my pleasure to thank designer Kurt Hauser and production coordinator Michelle Deemer, who have been brilliant, creative, and kind in our collaboration and in their efforts to lavish attention on this book. My thanks also extend to freelance copy editor Tom Fredrickson and proofreader Greg Dobie and to interns Estefania Valencia and Audrey Warne.

Elizabeth Nicholson, the editor of this publication, first approached me about producing a printed version of the *Getty Black Book* just days after the original was bound and donated to the GRI; she may have had the idea before I did. Since then she has been steadfast in keeping this book on the radar and on track and has approached the project with a devotion rivaling my own. I thank her from the bottom of my heart.

Finally, I wish I could thank and share this book with my high school friends—long lost in many ways—who led me to the intoxicating air of the aerosol arts.

David Brafman

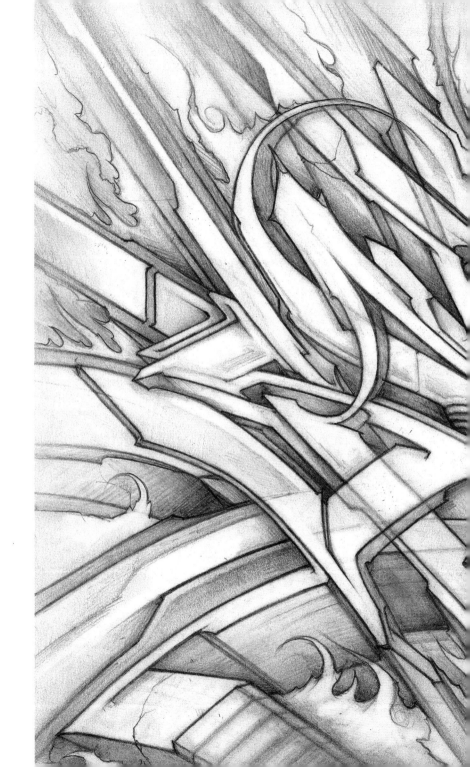

Getty Research Institute Publications Program
Mary Miller, *Director, Getty Research Institute*
Gail Feigenbaum, *Associate Director*

© 2021 J. Paul Getty Trust

Published by the Getty Research Institute, Los Angeles
Getty Publications
1200 Getty Center Drive, Suite 500
Los Angeles, California 90049 1682
getty.edu/publications

Elizabeth S. G. Nicholson, *Project Editor*
Tom Fredrickson, *Copy Editor*
Kurt Hauser, *Designer*
Michelle Deemer, *Production*

Distributed in the United States and Canada by the University of Chicago Press
Distributed outside the United States and Canada by Yale University Press, London

Separations by iocolor, LLC, Seattle
Printed in China by Artron Art Group

Library of Congress Cataloging-in-Publication Data
Names: Brafman, David, 1955- author.
Title: L.A. graffiti black book / David Brafman.
Other titles: LA graffiti black book
Description: Los Angeles : Getty Research Institute, [2021] | Summary:
 "This book features reproductions of 143 drawings by 151 Los Angeles
 graffiti artists that were done as part of a collaborative
 project known as the Getty Black Book. An introductory essay
 provides context for this black book and examines the Los Angeles
 graffiti scene"—Provided by publisher.
Identifiers: LCCN 2020041910 | ISBN 9781606066980 (hardcover)
Subjects: LCSH: Drawing, American—California—Los Angeles—21st century. |
 Graffiti artists—California—Los Angeles. | Graffiti—California—Los
 Angeles. | Street art—California—Los Angeles. | Tattoo
 artists—California—Los Angeles.
Classification: LCC NC138.L68 L3 2021 | DDC 751.7/3—dc23
LC record available at https://lccn.loc.gov/2020041910

Front cover and p. i: LA monogram by Prime
Back cover: background, Big Sleeps; top, Enk One; middle, Kwite One; bottom, Heaven
p. ii: Gasoline (detail); pp. iv–v: Prime (detail); p. vii: Blosm and Petal (detail);
p. ix: Defer (detail); p. 165: Saber (detail)

David Brafman is associate curator of rare books at the Getty Research Institute. He coedited and contributed to *Alchemie: Die Große Kunst* (Staatlichen Museen zu Berlin, 2017) and contributed to *Cave Temples of Dunhuang: Buddhist Art on China's Silk Road* (Getty Publications, 2016). He holds a PhD in classics and Arabic from Duke University.

Illustration Credits

Every effort has been made to contact the owners and photographers of illustrations reproduced here whose names do not appear in the captions or in the illustration credits listed below. Anyone having further information concerning copyright holders is asked to contact Getty Publications so this information can be included in future printings.

Unless otherwise noted, copyright in each work of art is held by the artist.
Photographs of works in the *Getty Black Book* by Curt Grosjean, courtesy Ed and Brandy Sweeney
Fig. 9: © Jim McHugh
Figs. 10–12: © Gloria Plascencia Portraits, © ARTLAB21 Foundation / ESMoA
p. 12: *LA Liber Amicorum*: LA monogram designed by Prime and digitally rendered by Kevin Hashizumi. Spine designed by Tony Sweeney.

Quotation Credits
p. vi, Enk One, "Merging . . . ": biographical questionnaire, 2013, Getty Research Institute; p. x, Kyle "Kyote" Thomas, "From blood . . . ": e-mail to author, July 1, 2020; p. 1, Abū Nasr al-Fārābī, "Letters exist . . . ": *Kitāb al-hurūf* (Book of Letters), quotation translated by author; p. 1, Angst, "Is graffiti . . . ": e-mail to author following a series of telephone conversations, July 5, 2020; p. 2, Chaz, "It took ten . . . ": Lorne M. Buchman, interview with Chaz Bojórquez, "Graffiti Artist Chaz Bojorquez on Straddling the Street and the Smithsonian," Change Lab (podcast, 12:28), produced by Christine Spines, April 8, 2020, http://www.artcenter.edu /connect/dot-magazine/articles/change-lab-ep-35-graffiti-artist-chaz-bojorquez.html, used by permission of the artist; p. 2, Defer, "My style . . . ": text message to author, July 12, 2020; p. 4, Angst, "I related . . . ": Danielle Sommer, "Artists of the Getty Graffiti Black Book on Style, Street Art, and Special Books," *The Iris* (blog), J. Paul Getty Trust, August 16, 2013, https://blogs.getty.edu/iris/artists-of-the-getty-graffiti-black-book-on-style-street-art-and -special-books/, used by permission of the artist; p. 4, AiseBorn, "The black book . . . ": e-mail to author following a telephone conversation, July 17, 2020; p. 5, Juan Carlos "Heaven" Muñoz Hernandez, "Art mirrors . . . ": conversation with author during a visit to Homeboy Industries to view a work on glass the artist had executed for the nonprofit organization; p. 7, Eric "King Cre8" Walker, "As a cocurator . . . ": text message to author following a telephone conversation, July 11, 2020; p. 8, David "Big Sleeps" Rodriguez, "Perfection in . . . ": telephone conversation, July 13, 2020; p. 8, AiseBorn, "The agility . . . ": e-mail to author following a telephone conversation, July 17, 2020; p. 9, Trigz, "Freeze means . . . ": printed on T-shirts by the Pebley family; information conveyed to author in a telephone conversation with Ed Sweeney, June 22, 2020; p. 9, Saber, "Graffiti art . . . ": e-mail to author, July 1, 2020; p. 10, Fishe, "The climate . . . ": e-mail to author following a telephone conversation, July 2, 2020, in response to an earlier telephone conversation; p. 10, Alex "Axis" Ventura, "Out of all . . . ": e-mail to author following a telephone conversation, July 11, 2020; p. 10, Prime: "There are many . . . ": e-mail to author following a telephone conversation, July 3, 2020; p. 11, Brandy Sweeney, "The black book . . . ": e-mail to editor, August 16, 2020.

OG Abel, Acme, Adict One, AiseBorn
Betoe, Big Sleeps, Blosm and Petal,
Cache, Cale One, Care One, Charlie
K4P, Craola, Craze, King Cre8, Crime
Demer One, Design9, Dr. Eye, Duem
Else, Enk One, ESK31, Estevan Oriol,
Gkae, Gorgs, Graff One, Green, Haste
Hyde, Jack, Jack Rudy (Mr. Huero), Ja
(Pranks, Method, Biser, Crae, Dsrup), K
One and Wram One, Kofie, Kopyeson
Kwite One, Kyle Kyote, Ler Keen, Lool
Mike Miller, Miner, Mister Cartoon,
Martinez, P.Chuck, Phantom, Phever, P
P17, Precise, Prime, Punk, Push, Pyre O
Rev, Rich One, Rick Ordoñez, Risk, Riv
Shandu One, Sherm, Siner, Skan One,
Spade, Spurn, Swank, Syte One, Telei
Tyke Witnes, Useck, Versus 269, Vox